PICTURING EDEN

First edition 2006

Co-published by the George Eastman House International Museum of
Photography and Film and Steidl Publishers, Göttingen, Germany.

ISBN 3-86521-207-7

Distributed D.A.P. Distributed Art Publishing, Inc.
155 Sixth Avenue, Second Floor, New York, NY
dap@dapinc.com

Picturing Eden was originally exhibited at George Eastman House International
Museum of Photography and Film in Rochester, New York, from January 28–
June 18, 2006.

This exhibition and publication were made possible with support from the Comer
Foundation, Creative New Zealand and Mondriaan Stichting

Publications Co-ordinator: Irene Rietschel
Editor: Dan Meinwald
Book design: Toki Design, San Francisco
Scans by Steidl's digital darkroom
Production and printing: Steidl, Göttingen

Steidl
Düstere Str. 4 / D-37073 Göttingen
Phone +49 551-49 60 60 / Fax +49 551-49 60 649
E-mail: mail@steidl.de
www.steidlville.com / www.steidl.de
ISBN 3-86521-207-7
ISBN 13: 978-3-86521-207-8

Printed in Germany

PICTURING EDEN

DEBORAH KLOCHKO

GEORGE EASTMAN HOUSE

STEIDL

ARTISTS

Greta Anderson
Wayne Barrar
Jayne Hinds Bidaut
Binh Danh
Susan Derges
Ed Dimsdale
Ruud van Empel
Adam Fuss
Sally Gall
Lyle Gomes
Gavin Hipkins
Matthias Hoch
Simen Johan
Izima Kaoru
Michael Kenna
Mark Kessell
Sally Mann
Han Nguyen
Lori Nix

Michael Parekowhai
John Pfahl
J. John Priola
Michael Rauner
Liz Rideal
David Robinson
Josephine Sacabo
Vincent Serbin
Jiři Šigut
Camille Solyagua
Alec Soth
Mike and Doug Starn
Hongbin Sun
Maggie Taylor
JoAnn Verburg
Terri Weifenbach
Jo Whaley
Masao Yamamoto

TABLE OF CONTENTS

Anthony Bannon, Director

Deborah Klochko

Merry Foresta
Deborah Klochko
Louise Mozingo
Rebecca Solnit

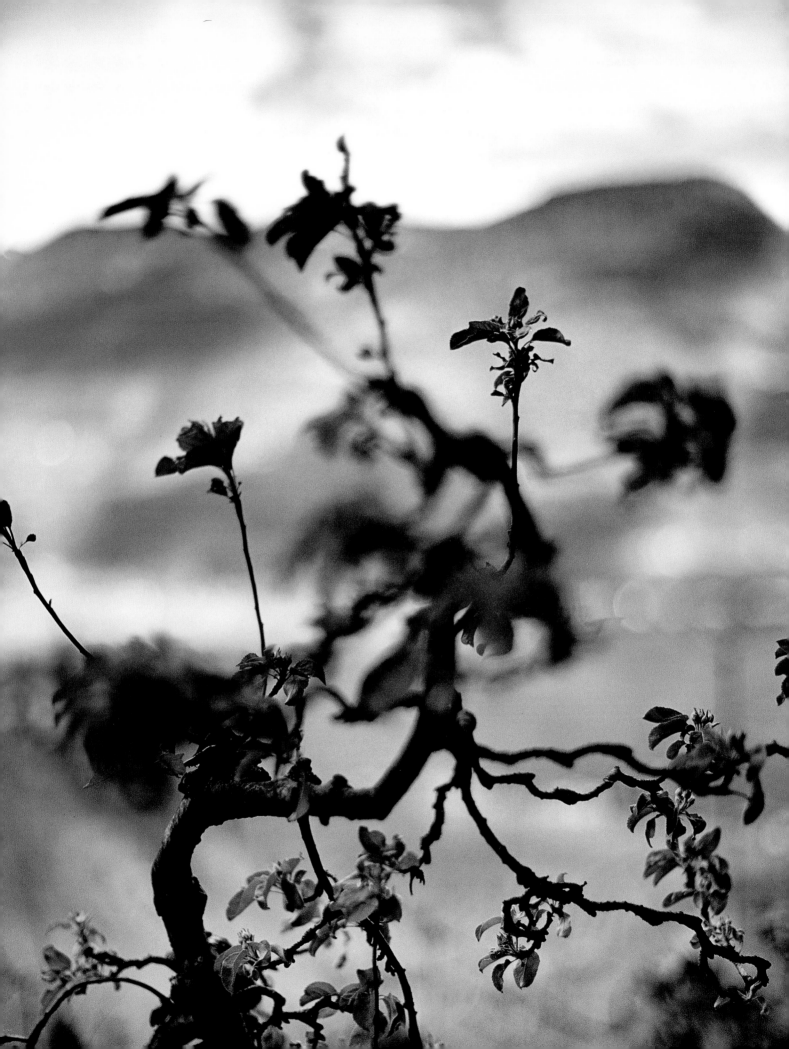

FROM THE GARDEN

THE BEST AND WORST ABOUT US GROWS IN GARDENS. We create them, learn stories of growth and decay from them, use them for contemplation and reflection. We gather in them as community. Gardens are a slow art. Their designs are often unrealized in a lifetime. Like theater and dance, gardens are made from living things, and they take time.

Gardens engage the large values of rhetoric and science. Their terms of engagement summon idealized compositions of unity, balance, and sequence.

Gardens are equally vain and self-centered. Shaped by the bold will of their makers, they take on the romance of humankind's desires for dominance. In the name of free expression, gardens share the arrogance of other arts, and their tropes—the tectonics of sculpture and architecture, the chronology of storytelling, the harmonies of music and poetry, even the memories of photography.

Just as it is impossible to simultaneously perceive the brushstroke and the figure, the note and its harmonies, one cannot view the flower and the landscape in the same moment. This derives from the human protocol of time, one moment after the other replacing the totality of an eternal moment. The garden visitor must suture component views into a sequential experience, articulated as the visitor moves through the garden's space like a film through its projector, streaming one image into the next, aspiring to the impossible beauty of the whole image. The visitor must hold one construction in memory, then another one, then the next, and the next, relating them by units of color here, texture there, then scale and vantage, and finally their connotations—first the pleasure of the specimen, then its emotional weight, shaped by the eye's mind.

Gardens carry metaphors as substantial as The Origin of Things. Artist-made gardens are Edens of creativity. They are designed places that aspire to God's grandeur and the notions that ensue. From ancient history through to our time, sacred groves have inspired visitors in all parts of the globe, orchestrating culture and its myths. Told by image and words, the stories of paradise, damnation, fertility, wisdom, and folly are brought into focus by the garden.

With one hundred thirty-three works by thirty-seven artists, curator Deborah Klochko argues the voices of Eden and its absence. *Picturing Eden* has been organized for international tour by George Eastman House. We are grateful for Ms. Klochko's vision and interpretive wisdom, all the more significant as war is waged in verdant Mesopotamia, said to be the first residence for woman and man in a place called Eden.

By Anthony Bannon,
Director, George Eastman House

Terri Weifenbach, *Lana Series #66*, detail, 1998-2001

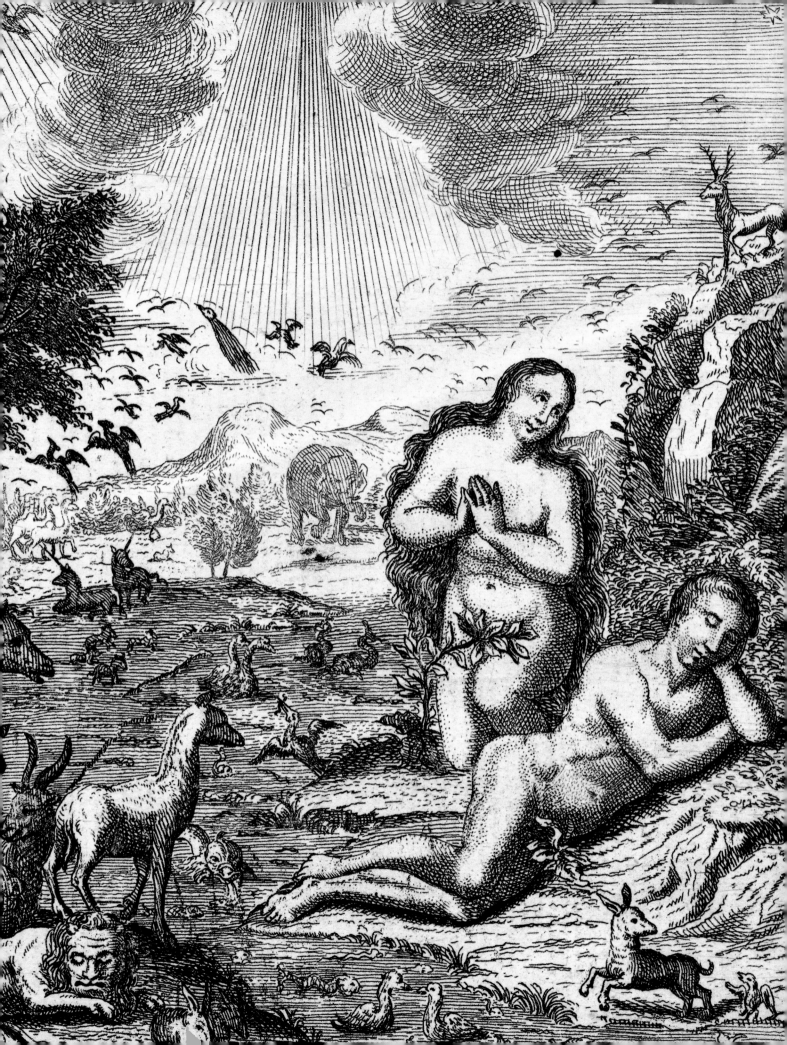

THE MYTH OF EDEN

Myth

"Where the tree of knowledge stands, there is always paradise": thus speak the oldest and the youngest serpents.

—Friedrich Nietzsche 1886

By Deborah Klochko

EDEN OR PARADISE REPRESENTS A MYTH OF AN IDEAL PLACE, a place set aside, removed from strife, knowledge and awareness. The story of Eden is one of loss and betrayal, with the devil, in the guise of a serpent, enticing the woman, Eve, to eat the forbidden fruit, causing both her and Adam to be banished from Paradise.

Reverse the myth of the Garden of Eden, and what do you get? The serpent is not evil, but a savior. Adam and Eve were not expelled from Eden, but escaped. The Garden of Eden is too perfect—a controlled environment where all was known and there were no surprises. Paradise is a prison, and Eve discovers that the awareness gained by eating from the Tree of Knowledge is the key to life. She becomes the first true explorer, looking for new ideas and experiences and demanding the opportunity to live, grow old and even die. The alternative, a never-ending sameness. "Now God must have known very well that man was going to eat the forbidden fruit. But it was by doing that that man became the initiator of his own life. Life really began with that act of disobedience."[1] By turning the myth around, Eve, in a single heroic act, allowed us to take control of our lives.

Eden—either as a place of perfect happiness and satisfaction or as a prison—is a concept that we still grapple with today. As a mythic theme, Eden resonates across time and cultures, and is charged with both political and environmental concerns.

One's cultural bias dictates the interpretation of myths, and this is especially true in the case of Eden. The myth appears in many cultures. The name changes, but most of the stories point to the Garden as the beginning, the place where it all began: "In Sumerian creation earth emerges from a watery chaos, and the gods planted a watered garden where humans lived in Paradise…humans shared a single language until the gods intervened to create a confusion of tongues."[2] The real devil is in the details. "The serpent sheds its skin to be born again…That's an image of life. Life sheds one generation after another, to be born again."[3] Was the serpent evil, or symbolic of the cycle of life? Does knowledge bring pleasure, or pain, or both?

With knowledge comes awareness, along with individuality and a sense of what has been lost, but it also brings an understanding that there is much to be gained. Innocence is gone, the future unknown but humankind has gained a lifetime of change from birth to death. Life is a finite journey, but one of adventure and exploration.

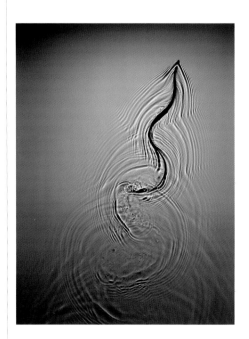

ABOVE: Adam Fuss, *Untitled*, 1998

OPPOSITE: Bouttats, [*Adam and Eve in Paradise*], detail, 1784

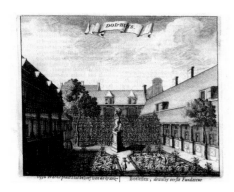

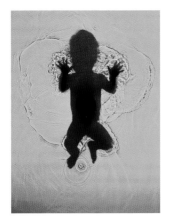 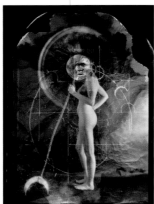

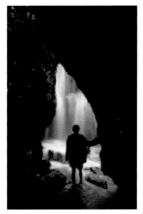 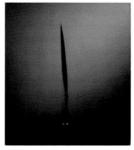

The photographers in *Picturing Eden* examine the many facets of Paradise, from a place of contemplation and restoration to a site of loneliness and despair. *Picturing Eden* focuses on the state of humankind after Eden. Paradise is no longer available to us, but from that moment on we have attempted to regain it. This has often taken the form of structuring nature in a controlled space or garden. In medieval times, the garden was symbolic, a place of perfection closed off from the real world. Streams and fountains represented redemption. Gardens were not only spiritual retreats, but places of pleasure and intellectual inspiration. As worldviews began to change, so did the garden. Nature was subdued by a new order and a more stylized approach, as a scientific method of observation and experimentation took hold. The formal garden represented control and reinterpretation of the idyllic environment, but no matter what form gardens took, they were— the Englishman John Evelyn, a founding member of the Royal Society and a well known gardener, wrote in 1629, the " place of all terrestrial enjoyments the most resembling Heaven, and the best representation of our lost felicitie."

Viewing the work of the thirty-seven artists represented here, it quickly becomes apparent that many of them are dealing with the idea of the garden as a metaphor for good and evil, heaven and hell. Picturing Eden is divided into four sections each reflecting aspects of concept of Eden. In **Paradise Lost**, the expulsion from Eden is equated with mortality. Adam Fuss' color photograms of a baby, represents birth or life, and eviscerated rabbits represent death. Vincent Serbin, in the work aptly named *Monumental History*, moves away from divine creation to the theory of evolution.

Paradise Recreated includes various attempts to remake that perfect place— "the desire to re-establish the paradisal state before the Fall, when sin did not yet exist and there was no conflict between the pleasures of the flesh and conscience."⁴ but that lost innocence keeps getting in the way. In Masao Yamamoto's jewel-like images there is a sense of isolation combined with an inescapable sensuality. Gavin Hipkins' work while visually lyrical, demonstrates to the viewer that nature is no longer on its own,

ABOVE: [*Garden of an Insane Asylum in the Netherlands*], Engraving, 1592

Adam Fuss, *Invocation*, 1992

Vincent Serbin, *Monumental History*, 1995

Gavin Hipkins, *The Homely: Te Wairoa (Falls)*, 1999

Masao Yamamoto, *A Box of Ku #522*, 2000

OPPOSITE: Matthias Hoch, *Paris #28*, 1999

Simen Johan, *Untitled #85*, from *Evidence of Things Unseen*, 2000

Lori Nix, *Wasps*, 2002

Wayne Barrar, *Cloned Plants (Tissue Culture) in Medium #2, Auckland*, 1996

Ruud van Empel, *Untitled #1*, 2004

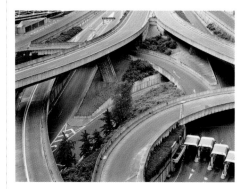

but marked by humankind exerting power and control.

The inevitable failure of the attempt to re-establish Eden is most evident in **Despairing of Paradise**. Lori Nix and Simen Johan present us with a world gone wrong. The earth has been turned upside down and insects reign supreme. In the work of Matthias Hoch, only a hint of Eden remains, ensnared in cages and man-made environments. In the *Cloned Plants* series by Wayne Barrar, man takes over completely, and in direct competition with the divine, works from the genetic level to recreate nature.

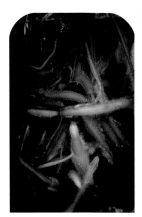

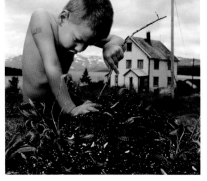

Finally, in **Paradise Anew**, "humans might blight the garden, but Eden never dies."[5] There is some hope of creating Paradise on earth, but it will ultimately be touched in some-way by our loss of innocence. Beautiful spaces can be created, and the conflicts of the world fenced out to some degree, but we can never regain our re-lapsarian state. The wide-eyed children in Ruud van Empel's photographs are in a pristine, but sinister realm of nature. There is something hidden behind every tree and under every leaf. This new Eden is not so separate from the real world as we might hope. David Maine writing about Eve says, "For her part, the time of cer-tainty is over with, and she is not so sure of anything anymore." These children are not so sure either. "We're not in the Garden anymore, Eve giggles. She is aware in some part of her mind that giggling is inappropriate. But then, what isn't."[7]

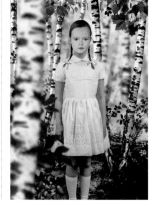

[1] Joseph Campbell, *The Power of Myth* (New York: Anchor Books, 1991): 60.

[2] Bruce Feiler, *Where God Was Born: A Journey by Land to the Roots of Religion*, (New York: William Morrow/ HarperCollins, 2005):168.

[3] Campbell, *The Power of Myth*, 53 (see n. 1).

[4] Mircea Eliade, *The Sacred and The Profane: The Nature of Religion* (New York: Harcourt, Inc.,1957): 207.

[5] Feiler, *Where God Was Born*, 156. (see n. 2).

[6] David Maine, *Fallen* (New York: St. Martin's Press, 2005):243.

[7] Maine, *Fallen*, 239 (see n. 6).

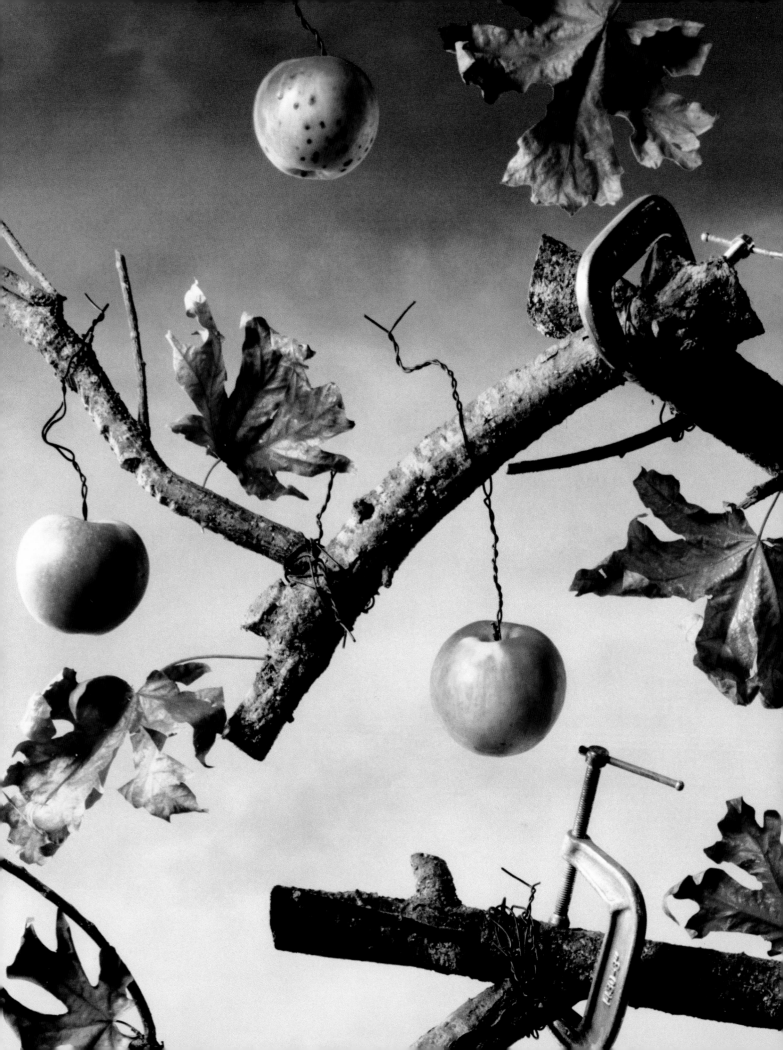

VISUALIZING PARADISE:

A CONVERSATION

The conversation participants are Merry Foresta, director, Smithsonian Photography Initiative; Deborah Klochko, curator; Louise Mozingo, associate professor, Department of Landscape Architecture at UC Berkeley; and award winning author Rebecca Solnit.

MERRY FORESTA: I have been a curator of contemporary photography for the last twenty years, and I guess that—aside from experience—my credentials coming in to this project would be an exhibition and book called *Between Home and Heaven: Contemporary Landscape Photography*, a project that I did in the late 1980s, early 90s. One of the reasons I became interested in the topic was that the most interesting images I was encountering were about landscape. There seemed to be a critical mass being formed about landscape as a subject. In looking into it, I saw that there was a broad range of approaches to landscape that were both historical and partaking of newer interactions between photography and art. Since doing that project, I have acquired a large piece of land in the Shenandoah Mountains of Virginia. As I sit on my front porch, I am acutely aware that although it seems very natural and very far from anything urban, all of it is constructed, all of it "touched" in some way. I sit on what was once thought of as the western frontier—how quickly they lost that notion! Also, working in the garden, I have realized how hard the garden is to maintain as a construct, quite literally.

LOUISE MOZINGO: I am both a landscape architect and a landscape historian, so I deal daily with the notion of the garden in history and how the garden transmutes through history. Eden, or Paradise, or the idealized landscape is tied up in the changing vision of good order throughout history. At every given moment, there are forces that change that notion. We seem inevitably drawn to trying to figure out what good order is—the ideal garden. What intrigues me about the garden is the expression of Paradise, and in particular, the dimension of spiritual practices, from the Zen garden to the noble garden to the cloistered garden. We can say that the American National Park is a kind of spiritual garden. An idea of landscape also comes across through those visions. We think of the garden as paradise.

REBECCA SOLNIT: I discovered my passion for natural places, plants, botany, landscape, garden, etc. in my mid twenties. I traveled to it in some ways through landscape photography, particularly the work of Linda Connor. I met Linda first, then I met Meridel Rubenstein, Richard Misrach, and eventually Mark Klett, along with a number of other people who were landmark figures for the redefinition of landscape in that era. I went back to Yosemite recently, working with Mark Klett on a re-photography project in which we photographed the same scenes that Carlton Watkins, Edward Weston, and Ansel Adams photographed in the past, attempting to turn what is often seen as virgin wilderness into a cultural landscape. These complex politics about embodiment, place, geography, and nature as it is manifested in landscape—but not limited by landscape—

Jo Whaley, *Harvest, the Fall*, detail, 1992

have been key in my writing, whether it is about walking, wanderlust, Muybridge and the Indian Wars in the nineteenth-century West, or the acceleration of time and space.

MF: Are you saying that you have moved away from the specifics of landscape—of it being a particular place—to its importance in terms of larger, more abstract concepts like time or place, or a more ritualized use of a place?

RS: It's less that than the fact that I started writing about people who were dealing with place. I wrote about site-specific work and installation art and landscape photography, eventually writing about geography, landscape, environmental politics, and the places themselves. Rather than looking at Richard Misrach's Nevada test site project, I wrote about being at the Nevada test site and the history of the site without Richard as an intermediary. I went from representations to having my feet in the actual dirt (radioactive, non-virginal) and thinking about where landscape photography can go from there. I wonder where landscape photography has or hasn't gone since the *Between Home and Heaven* project? Because I don't see a lot of landscape photographers in the conventional sense who are under 35 or 40 years old.

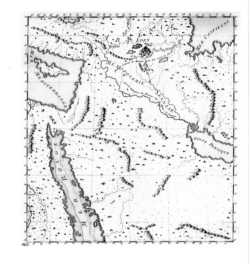

MF: I think that landscape photography has retreated to a neo-romanticist approach, but I find that a younger generation has really engaged with off-site use of the subject of landscape, whether it's creating spaces in their studios which reference the landscape or taking natural materials and creating objects to be photographed. The landscape has moved to an off-site location, quite often a studio, or more recently a computer. Rather than finding constructed landscape, you construct it yourself.

Deborah Klochko: *Picturing Eden* is about perceptions of the garden as an Eden—not a natural environment but a manipulated, fabricated place. Our banishment from Eden was the end of innocence. The introduction of photography brought an end to the age of visual innocence. I am interested in photographers who turn their cameras to these manipulated environments and then take it a step further—not even dealing with reality. *Picturing Eden* is not about documents of gardens, but it is about defining Paradise or Eden

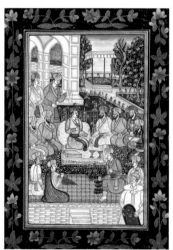

through the lens of the camera. There is a Biblical sense of Eden and Paradise, but there are very modern interpretations of these terms. We know that the word Paradise is from ancient Persian, and whether it was Judaism, Islam, or Christianity, they all had a version of a Paradise.

LM: The original source of the word "garden" is the Indo-European "gert," which means fence—setting something aside, and that's the key. That notion of setting aside was extremely literal at first. There was either agricultural land or wilderness, then you set aside this garden that was not quite agricultural land. The Epic of Gilgamesh describes the city of Uruk as one-third field, one-third city, one-third garden. They were already making a distinction between field and garden. So there is this notion of separation, and the garden is not only utilitarian. Eventually it becomes less and less utilitarian, and more about expression and metaphorical narrative. That is really what distinguishes a garden. There is a point in which the fence begins to fall away. First, the Italians bring in the distant view. This is in the Western narrative—there is a different narrative in the East. In the distant view, the edge becomes the viewpoint outward. The French extend the boundary so far that it is not visually understood any more, and of course the English hide the fence. In this perspectival manipulation, the British bring in agricultural

[Map of Mesopotamia], from *Atlas Historique et Geographique,* 1762

[Indian Miniature Painting], n.d.

land as a part of the composition, so the garden becomes the edge of the imagination, no longer the edge of the landscape.

MF: Is the idea of the imaginative location an eighteenth-century, seventeenth-century, or Enlightenment idea?

LM: I would say it's eighteenth-century. That's when you get associations of the garden that are moral and political. At that point, the garden becomes attached to a kind of moral order, so you have the equation of the garden and goodness. This notion of moral order is prevalent in the eighteenth century, and it's something that Americans are immersed in—that notion of greenness and goodness, in part because we have this spacious landscape. We have this vision of unlimited landscape, which is a really important tradition. There is no longer a boundary—you have the city as garden, and the term landscape becomes much more generic as well. Today, we talk about all kinds of landscapes, including the digital landscape and the electronic landscape.

MF: An important distinction to consider is the issue of garden as opposed to landscape. Because one of the interesting things about this project is that it is defining itself around the idea of garden, which is a specific space. There are different expectations of garden than of there are of landscape.

DK: The focus of *Picturing Eden* is on the garden, a more contained, more controlled space rather than the landscape. The artists involved are specifically exploring notions of Eden, Paradise, and the successes and failures of attempting to recreate them.

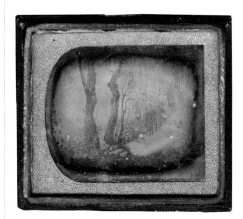

MF: When I began to look at a lot early photography in the United States, I was amazed to see as many outdoor photographs as I did. I was also amazed to see how many people took the trouble to go out and photograph their garden. The only other subject that seems to have been very close to that was gravesites. Cemeteries looked very gardenlike, and they were very ordered spaces with fences around them. I very quickly realized that there was a metaphoric relationship between the garden and a funereal site—a site of something having passed. It was a moment in history when the wilderness was being gobbled up. We tend to think of it as having happened throughout the nineteenth century, but by the middle of the century there were already conversations and political discussions about the economics of the wilderness.

DK: Cemeteries were just another garden. People went there to enjoy themselves, to picnic and play. Our notion of cemeteries today is very different than it was in the nineteenth century.

MF: Oh, absolutely. That space was also set aside for contemplation, which set it off from the rest of the landscape.

RS: It makes you think of these images, not as descending from landscape paintings, as we traditionally think of them, but from memento mori—still life and things like that. One thing that is very present in these *Picturing Eden* pictures is that the artists are not very interested in space, which is the subject of a lot of landscape representation. They are much more interested in foreground and focusing inward. So often, the scale of landscape is such that if you are too far away, it's a map or an aerial, and if you are too close, it's a still life or portrait. There is a middle ground of looking at a vista, something with a horizon and a certain kind of expansiveness. There seems to be a socially constructed desire that comes as people get more and more removed from that space. I was looking for a place to live, and I wanted a room with a view. Meridel Rubenstein's husband, Jerry West, laughed and said, "You know, if you want a view, go outside." He had the attitude that if you can

[*Cemetery*], daguerrotype, c.1850

be out all day long, why do you need the picture? There is a sense that a representation replaces something that's lost. There is a kind of longing that is often associated with landscape, even when it's not really lost, and that longing may be one of the key pleasures of landscape.

LM: I associate it with a yearning for order. That is what photography does—it orders things for a moment. Why do we feel soothed, calmed, centered in the garden? Because implicit in the garden is a sense of order. All of the disorganization of life outside of the garden gets put aside for the moment. There are eccentric gardens that are not about order, but about disturbance. The classic ones in Italy form these incredibly disturbing images and manipulations of balance that literally make you nauseated.

MF: Many of the images collected in *Picturing Eden* seem to be about gardens, but are really about something else. That something is disturbing, or not quite right, so that the viewer really benefits from a closer look into these gardens. What I am responding to is the notion that the barriers between garden and landscape have fallen away, and there is this sense of a garden out of control.

LM: I have noticed that many of the photographs included here are studio compositions. Unlike the vast majority of gardens that are searching for stasis or centeredness, they are more about the disturbed or eccentric garden, the garden that challenges and expresses the disconcertion of life. It strikes me that they are trying to turn what was a smaller theme in actual gardens into a big theme in photography.

RS: Was it William Kent in the eighteenth century who saw England as a garden? If you pursue the Romantic idea of nature as orderly, then environmental and ecological theories supply us with a counter-narrative in which human beings don't create order out of chaos, but chaos out of order. In that sense, these human-manipulated landscapes are very much about disturbed nature. In some ways this is reassuring, because what is disturbing about this work is how removed it seems from the paradigmatic problems of the day.

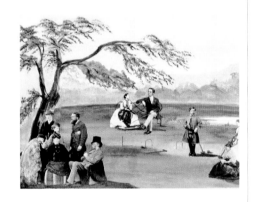

MF: Some of the photographers that have been selected actually use nature—the elements, the garden itself—as part of the process of making the picture. They are implicating nature in its own picturing, which I find a very interesting contemporary idea. This makes the statement that we can't do something about nature, or to nature, but we have to do something *with* nature. Perhaps where we've gone wrong is in separating ourselves from nature, or separating ourselves from the picture of nature and the garden.

RS: What is so interesting about the work of Susan Derges and Adam Fuss is that sense of returning to nineteenth-century processes that use photography that way. You are incorporating not just biological nature, but the nature of physics that deals with light as part of the environment. There are all these wonderful terms used in photography: Sun Pictures, Sun Drawings, the Pencil of Nature.

DK: One of the reasons I like Wayne Barrar's work is the nineteenth-century sensibility he incorporates into twenty-first-century subject matter. The cloned plants he photographed represent a new technology and point to the weird future of nature. Eden can now be made by the hand of man, who in a sense is taking over nature's own process.

Constance Sackville West album, 1867

Wayne Barrar, *Cloned Plants (Tissue Culture) in Medium #4, Auckland*, 1996

His work truly represents innocence lost. Ruud van Empel's images of young children in all-encompassing forests speak to what this whole project is about. He has gone back to the garden and reclaimed it, but true innocence is gone.

MF: We have to be careful, because what's gone is our innocence in being able to look at a picture like that and accept it as innocent. We have the responsibility to, in some way, bring back to these pictures a certain kind of knowledge that we gained when we left the garden. We are compelled to bring all of our experience of the world to the picture when we look at it.

RS: His vaguely pornographic deployment of little girls in a Lewis Carrollian way, as symbols of innocence and the fact that they look like fetishes of innocence, is really depressing. But maybe this is a time to problematize Eden and innocence, both of which are really interesting social and political constructs. James Baldwin, talking about white people who didn't know what racism was doing in America, once said, "It is the innocence that constitutes the crime." I think there is a way you can critique innocence. It is the desire to not know the value of innocence that is really problematic. There were a number of poetical cults that interpreted 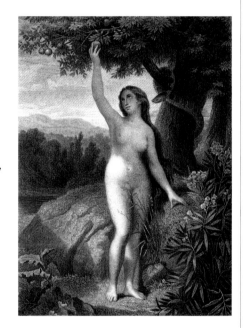 Eve not as the bringer of sin and death to mankind, but as a liberator of human beings from a kind of pre-human condition in which they did not have knowledge or freedom of choice. The intensity of experience that comes after innocence means that you are human and really alive. That's one thing, then Eden is a problem, politically in this country, referring back to some paradise lost, whether it is the eco-feminist talking about matriarchal agricultural societies or the male anthropologist talking about hunter/gatherers and the paradise that we fell out of into agriculture. Or we construct Native Americans as living in Eden before the fall.

MF: There is this idea that somehow native cultures, in their primitivism, are somehow closer to nature.

RS: One of the great contributions Native American culture makes to this discourse on Eden is that there is no Eden in their creation stories. It's all experiment and improvisation. Things go wrong and you fix them. Things were never right to begin with, so there is never a fall from grace, and you are never mourning a perfect lost world. When you stop mourning paradise you enter a very different construct, although a lot of the paradise we see here is a kind of nostalgia for a version of childhood rather than for some collective cultural paradise. That itself is problematic. I always say that perfection is the stick with which to beat the possible. People hold up the Ansel Adams photograph as an example of the perfect landscape, against what Yosemite actually looks like. You don't go around with red filters on your eyes, and it's not always the moment after a storm has cleared.

MF: If you find where Ansel Adams and Carlton Watkins and all the rest stood, you can find the view. People absolutely accept truth in the photograph. We are not so innocent as to think that photographs always tell the truth, but they do tell us certain kinds of truths. The context in which you choose that truth becomes a very important and implicit challenge for a lot of photographers.

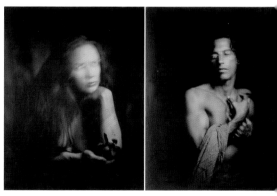

[*Eve in the Garden of Eden*], steel engraving, 1881
Jayne Hinds Bidaut, *Portrait of Eve*, 2001; *Portrait of Adam*, 2001

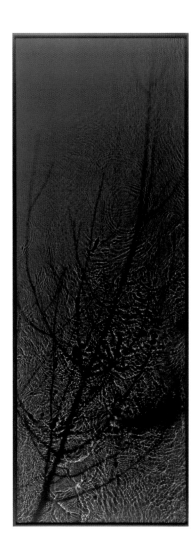

RS: One of the fun things about re-photographing Ansel Adams with Mark Klett was discovering how often Adams turned his back on the parking lot. The parking lot is behind the sublimeness, and through re-photography you find out that *Clearing Winter Storm* was taken six feet below the retaining wall of a big tourist site. I am always amazed how people edit their experience. You learn to edit it with a tourist camera, and Ansel helped show us that. It's not judgment about you, or photography, but I am fascinated by how we edit our experience. It's probably entirely natural.

MF: I don't think we do edit our experience. Those people who were looking at the pictures had already edited their experience and were matching their experience to the photo.

LM: More recently, the focus is on moving beyond preserving these sublime wilderness areas. There has been this return to looking at the landscape we ordinarily live in and not seeing that as degraded. In the United States, the environmental movement is big on the ethics and the morality of the wilderness.

RS: Virgins and whores…

LM: It is all virgins and whores—it doesn't enable us to think about tending the whole landscape for environmental health, and there has been a huge shift in the last twenty years in how people understand that. One key text is *The Granite Garden*—seeing the city as an ecological system. It is a highly constructed ecological system, but it is an ecological system. The perceived problem with the built environment is that it is disordered and not worth tending.

RS: I am one of the last generation of kids who had absolute free range, and could do anything they wanted. We lived on a subdivision where there was nothing but dairy farms and open space for several miles in every direction, and that was all mine. Looking at these pictures makes me realize the transformation that has taken place. Today, parents don't let their kids go anywhere by themselves, and that's one of the big questions for the environmental movement. That passion for open space and adventuring and exploration and wandering around and getting lost is so formative in childhood. What happens to a generation that has never been allowed to go out of doors in an unstructured way?

MF: That brings up another use of the garden that is not so American, which is exploring creeks and gathering tadpoles. It's more the European model, which people do in dense urban areas. The public park as garden becomes another space useful for the family units, in which people gather at the end of the day or on weekends. There is no room in your apartment, so you bring your kids out and everybody plays together in the communal space of the garden.

RS: The European sense of nature is very interesting, that it's public and social space, whereas Americans are so obsessed with nature as an antisocial space.

DK: An interesting parallel between photography and the idea of the garden is the factor of editing. The editing of the environment mirrors the choices that the photographer makes—where they place the camera, where they point the lens. Like photography, the garden requires that choices be made, a kind of editing of nature to create the finished piece. You can also draw comparisons between the garden and painting, but again, photography brings this overlay of reality that I think is incredibly powerful.

MF: We talk a lot about Western gardens. Would there be anything different about talking about Eastern gardens?

ABOVE: Susan Derges, *The Streens—Larch*, 2002

OPPOSITE: [*Untitled*], Japanese wood block print, 1885

Attributed to Felice Beato & Co., *Public Gardens at Uyeno—Tōkiyo*, 1875

[*Adam and Eve cast out of Eden*], from *Icones Bilicae*, 1648

LM: It is too simplistic to call a Chinese garden a miniaturization of the ideal landscapes found in the larger Chinese landscape. Rather, they are three-dimensional poems about those landscapes. Poetry is always integral, and narrative as well.

MF: That's interesting—the idea of a garden being created in relationship to an aspect of the landscape in which it sits.

LM: If you go to Japan, the garden is not so much an evocation *of* paradise as a means to go *to* paradise. Placing yourself in the space, or viewing that space, allows a state of mind that takes you to paradise, as opposed to physically being in a fragment of paradise—some imperfect, flattened paradise.

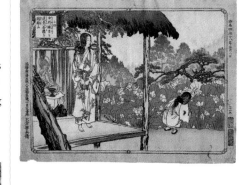

RS: Also, the aesthetics of intricacy and complexity are so far from the Cartesian, Versailles garden of symmetry and control. All those philosophical stones one contemplates are very narrow and intricate, and very much concerned with organic process, and with something other than perfection as an ideal.

LM: It's a different set of perfections because the Japanese garden is also exquisitely controlled. Individual leaves, not just trees, and individual stones, are sculpted for particular viewpoints.

RS: They are controlled, but they are controlled toward a very different aesthetic ideal.

LM: Absolutely. There is a different idea of what constitutes good form, but the aesthetic in both of them is equally controlled. If, as an innocent viewer, you view the apparent naturalistic quality of Japanese gardens, you don't realize it is as controlled as our gardens, if not more so.

DK: This brings us to the viewer experiencing the garden. A European viewing a Japanese garden is not going to read it in the same way that they read something like Versailles, because they don't have the visual vocabulary to understand what's being done.

LM: If you think about the opposite thing, the Japanese viewer viewing Versailles, they will immediately understand that it is completely controlled. I think that's the key difference in thinking about these two perceptions of gardens.

DK: We've covered a lot of territory in establishing definitions of Eden, talking about a multi-cultural approach to the garden and, quoting from Merry Foresta's essay, "our precarious relationship with nature."

RS: There is a desire to restore landscapes to pre-white contact, to remove the romantic ruins and traces of failed white endeavor and go back to some kind of pre-contact fantasy. The question becomes: Do you let them survive, and do you accept the complicated, engaged landscape, or do you roll back to some kind of Edenic fantasy?

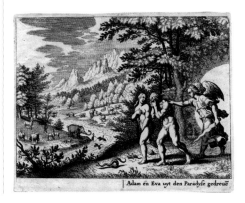

MF: More importantly: If we had the opportunity, would we want to go back to Eden?

RS: God, no! So boring, so ungrateful. We should thank Eve for the fall.

Paradise

P

Paradise Lost I SHOULD HAVE NO USE FOR A PARADISE IN WHICH I SHOULD BE DEPRIVED OF THE RIGHT TO PREFER HELL.—*Jean Rostand 1962*

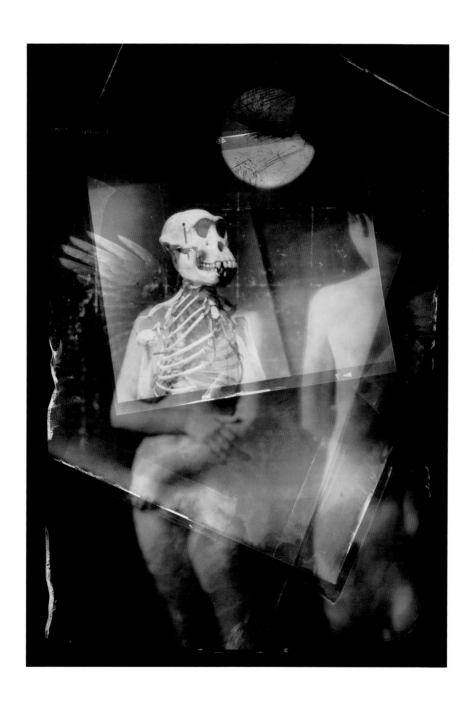

1 | *The Power of Imagination*, 1994

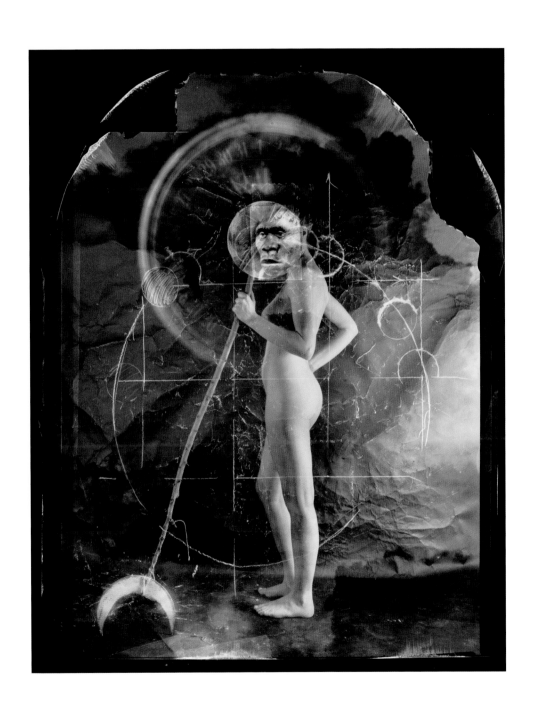

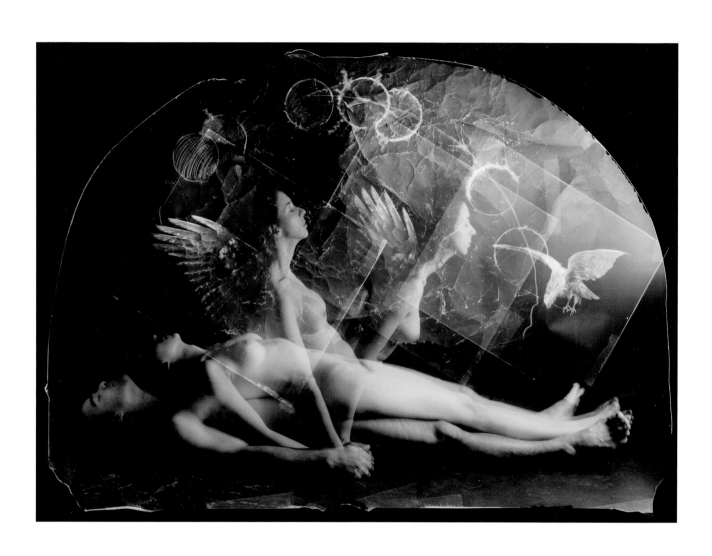

3 | *The Omega Point Theory,* 1998

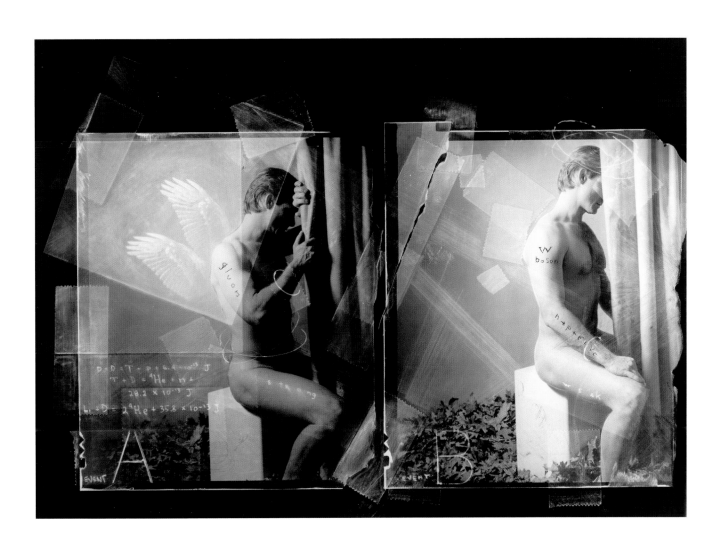

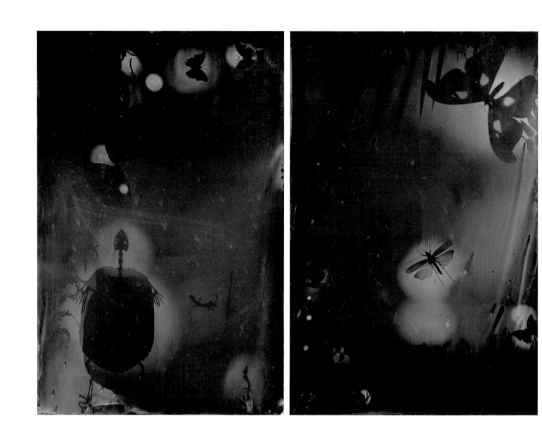

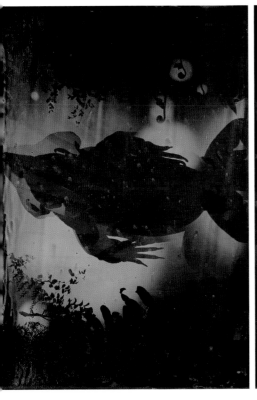 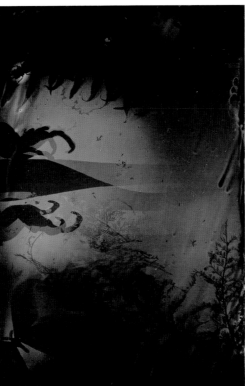 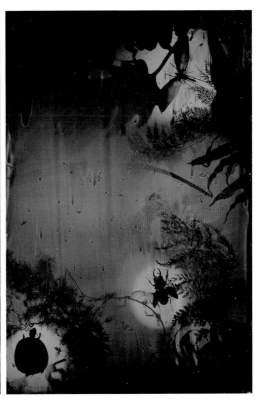

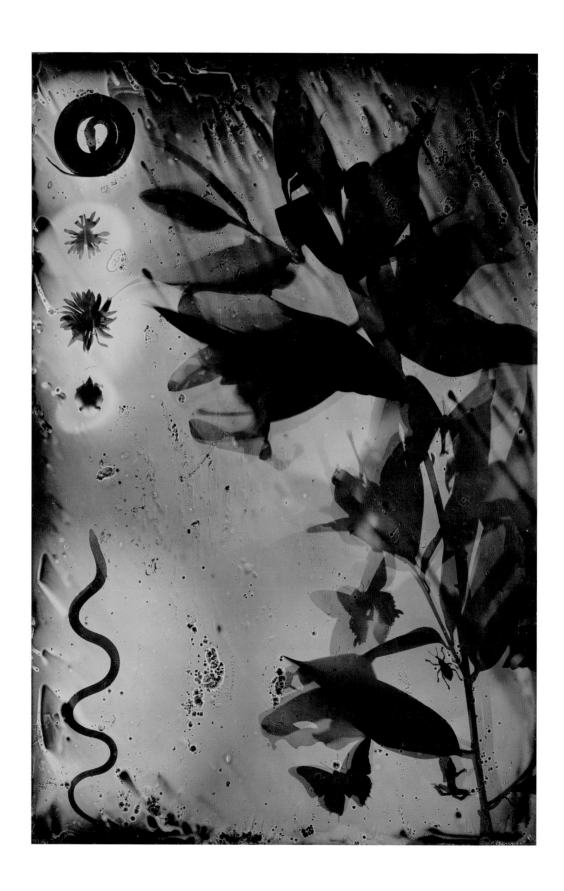

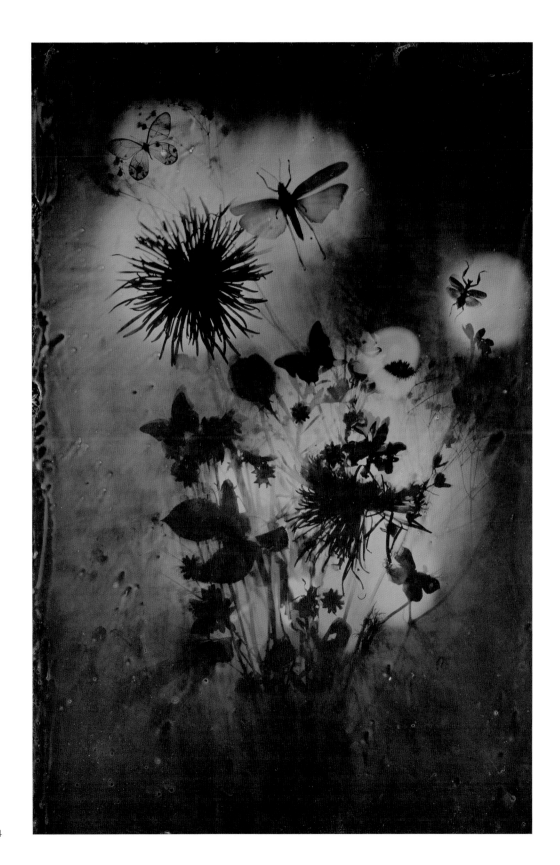

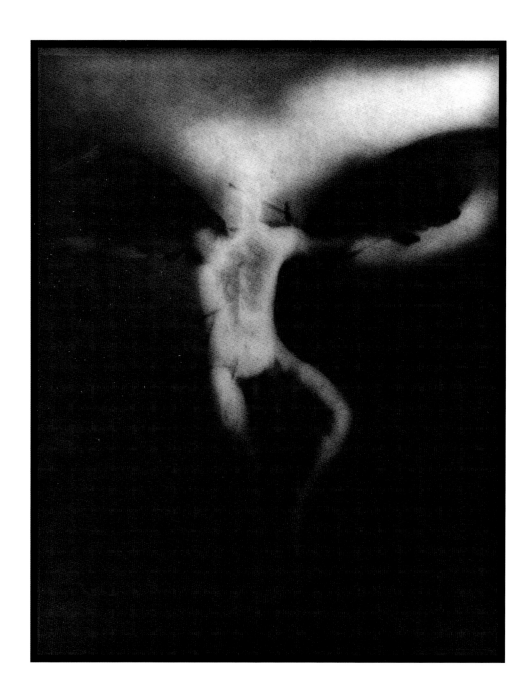

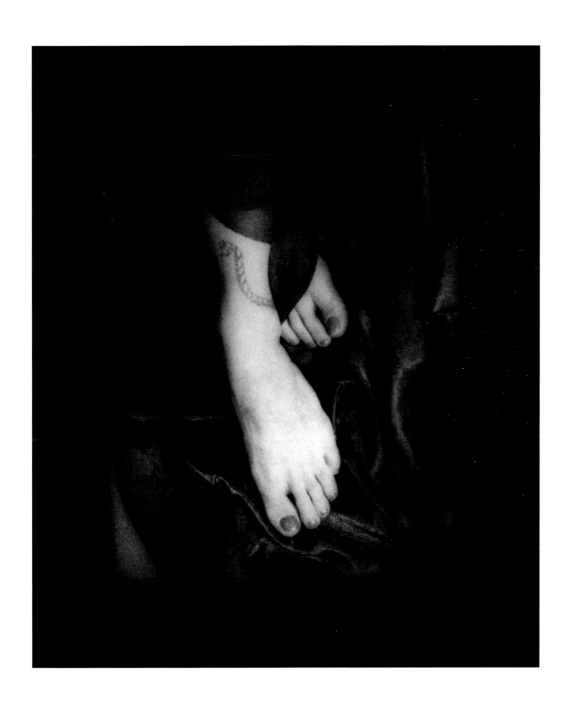

9 | *The Serpent*, 1990

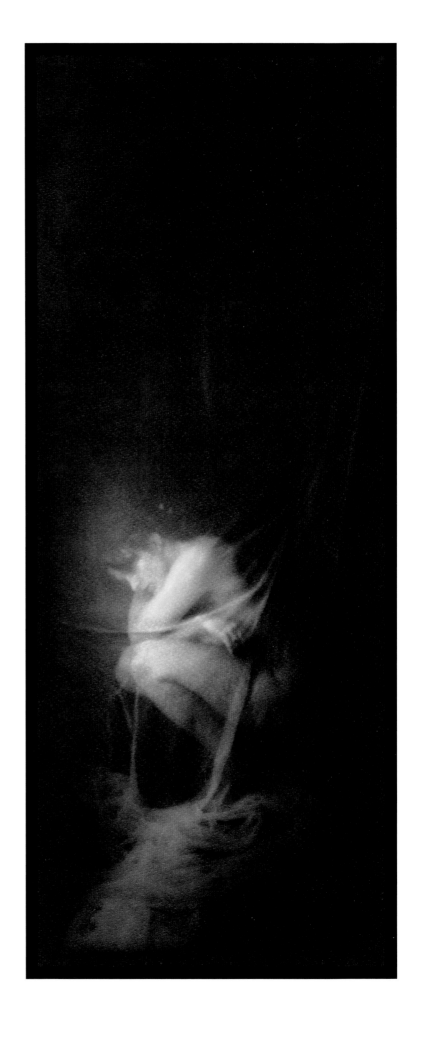

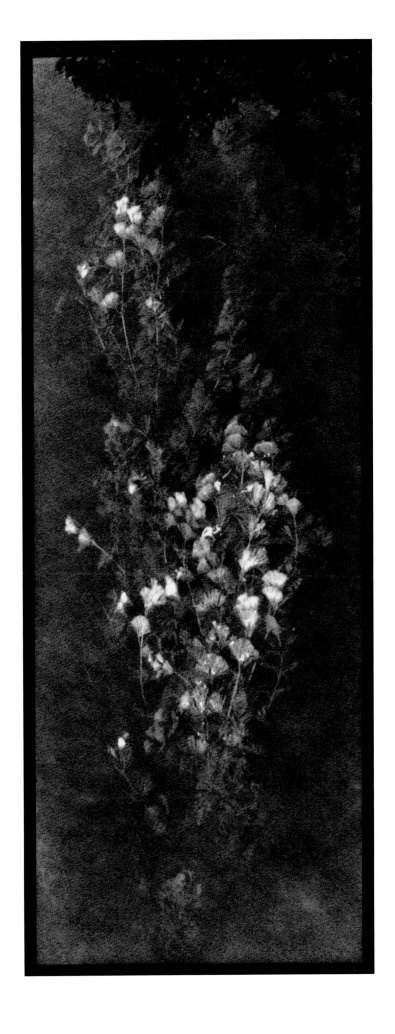

11 | *Bouquet,* 2003

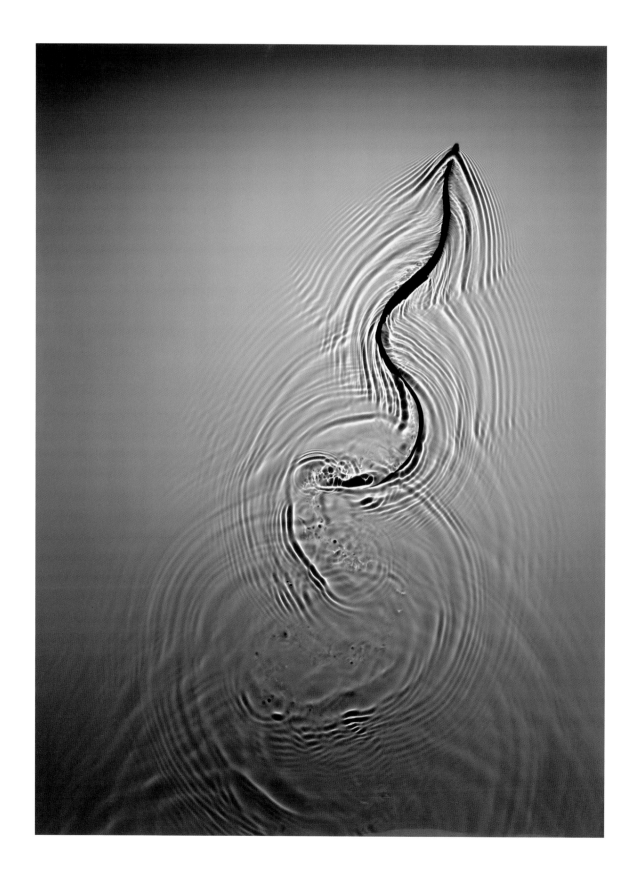

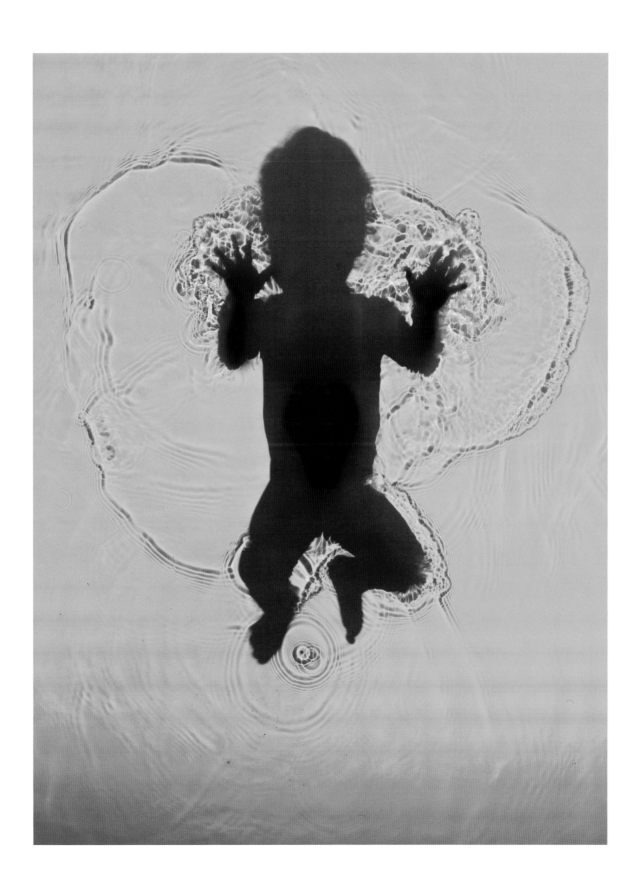

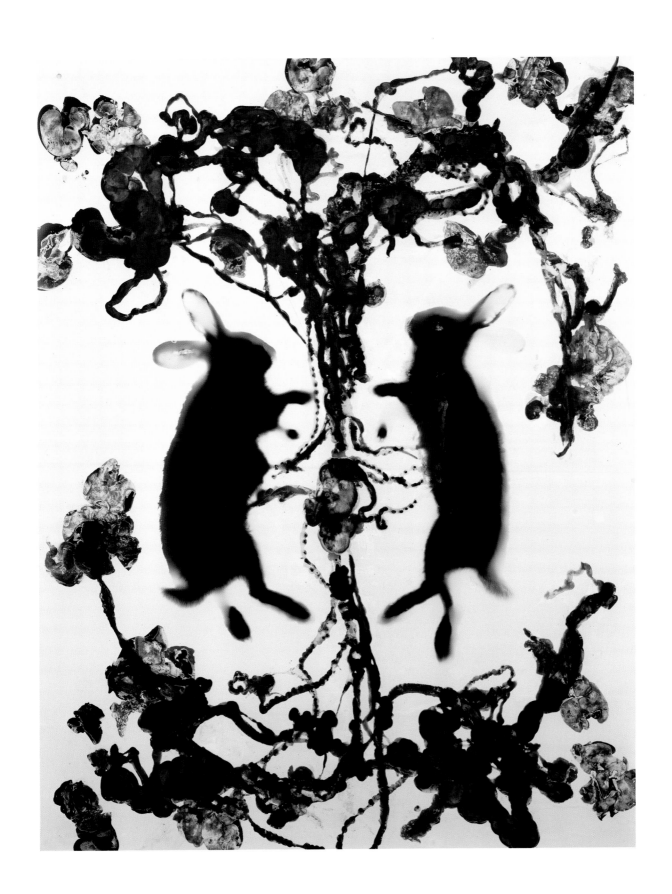

15 | *The Residue of Vision*, 2003

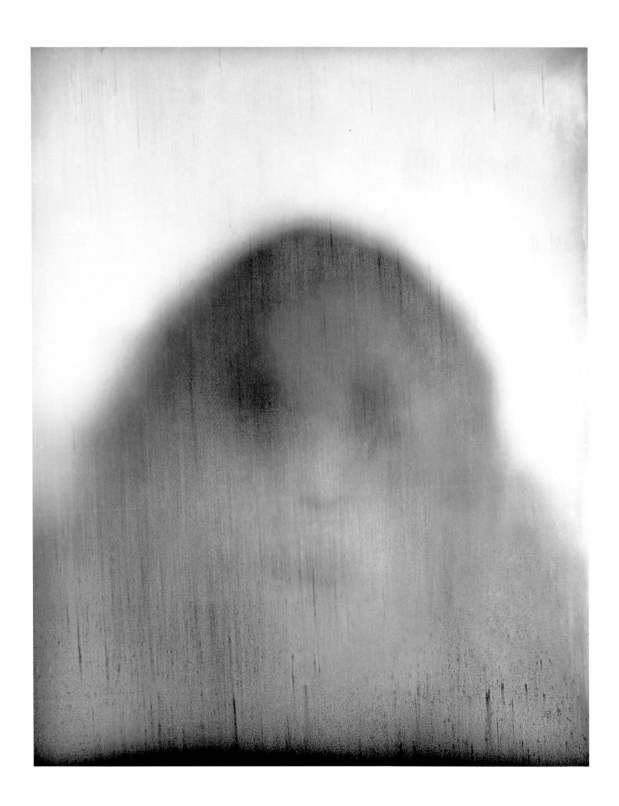

17 | *Coelenterate*, 2003

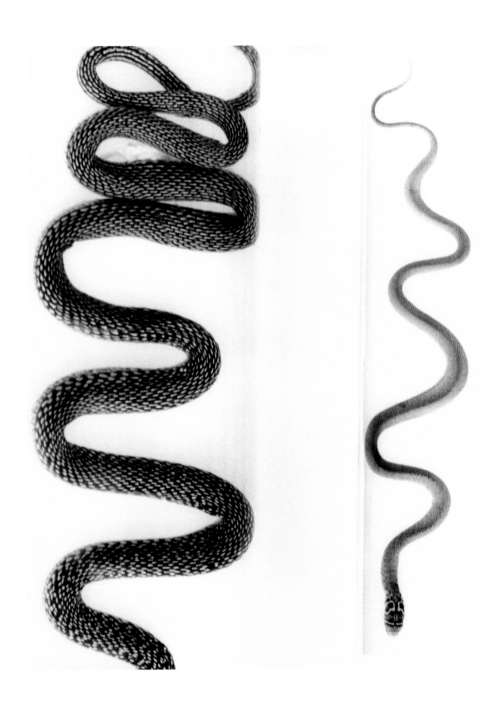

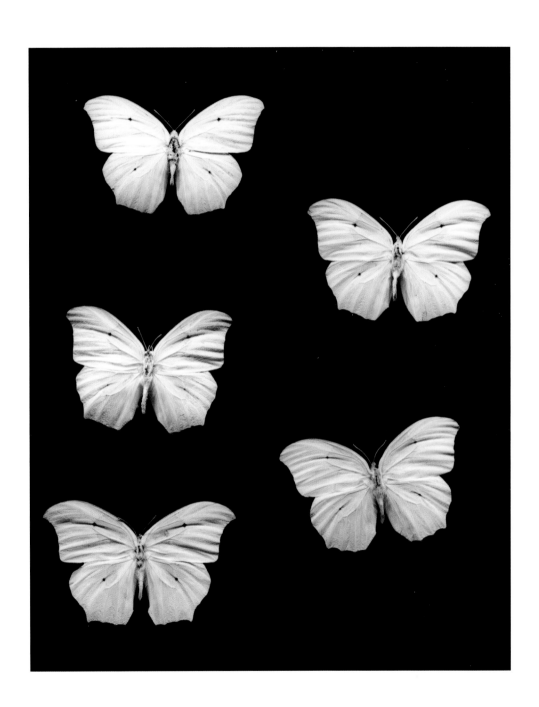

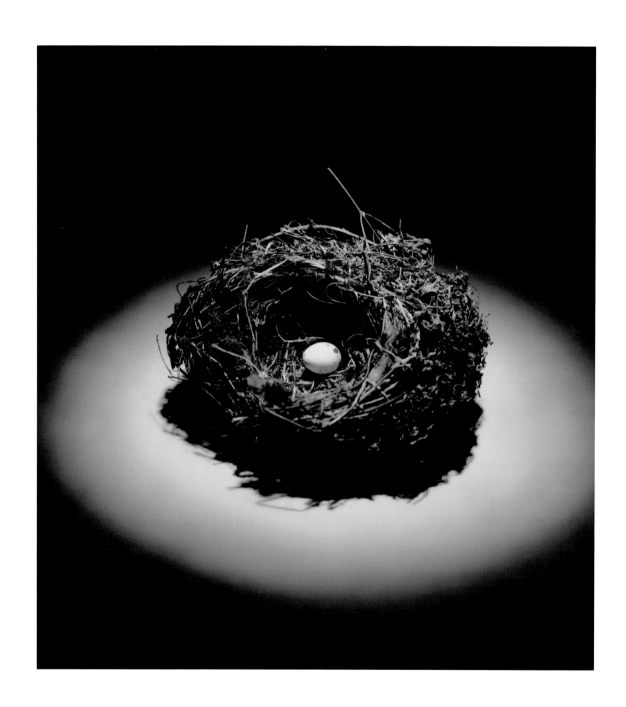

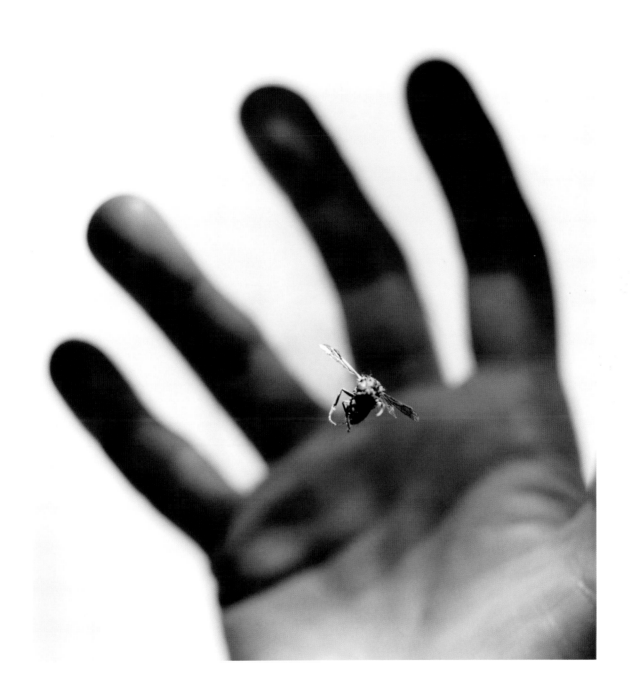

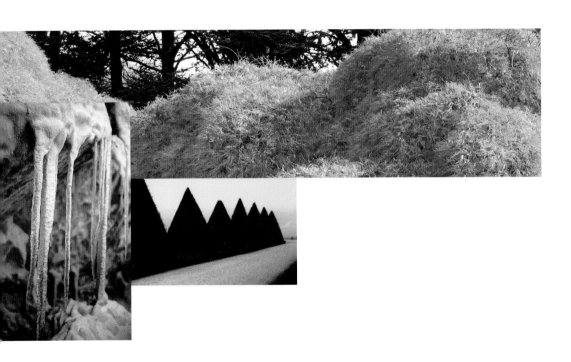

Paradise Recreated

DARK WITH EXCESSIVE BRIGHT.

—*John Milton 1600s*

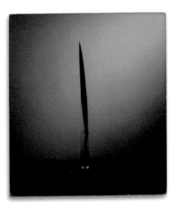

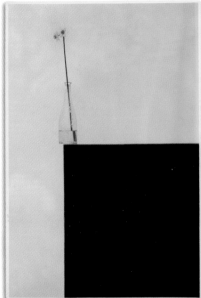

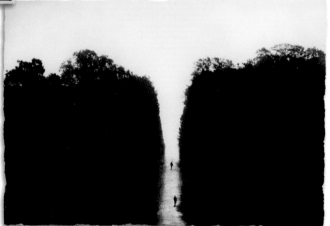

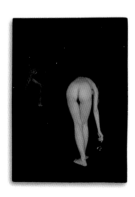

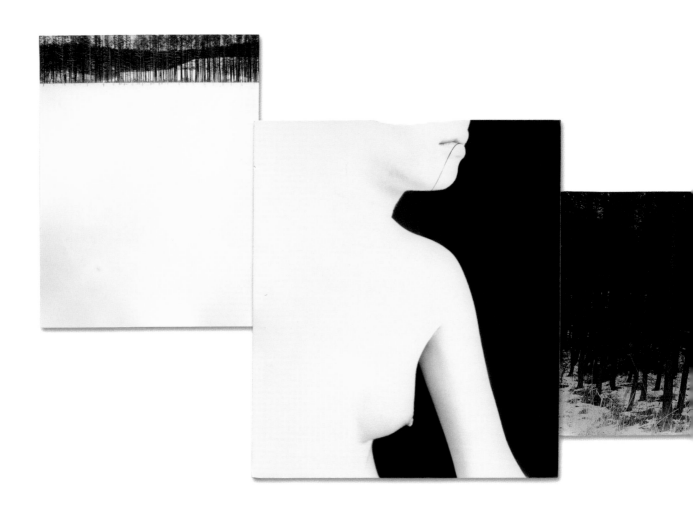

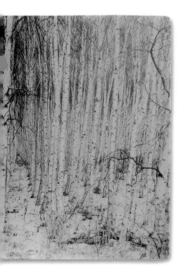

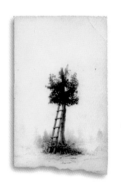

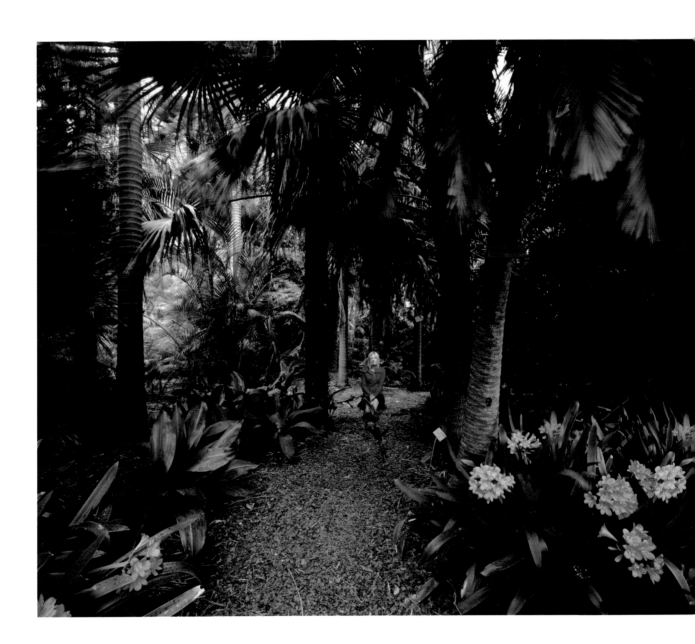

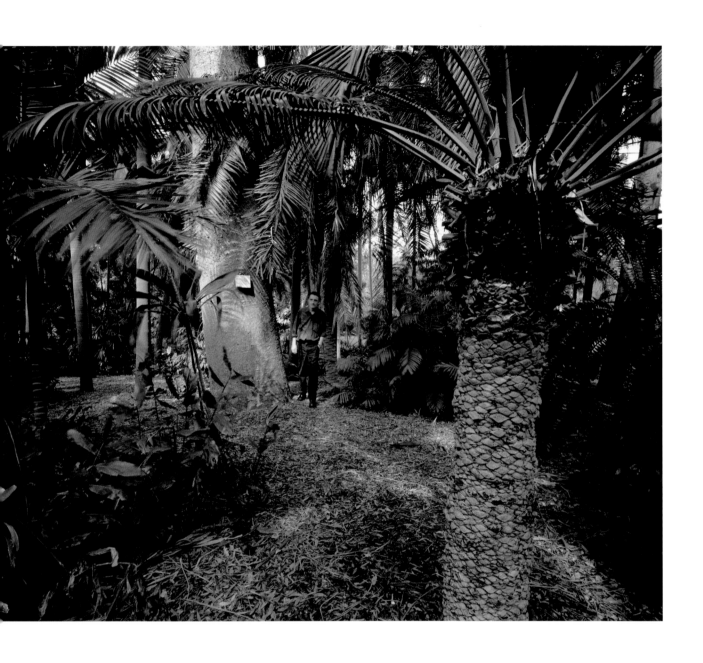

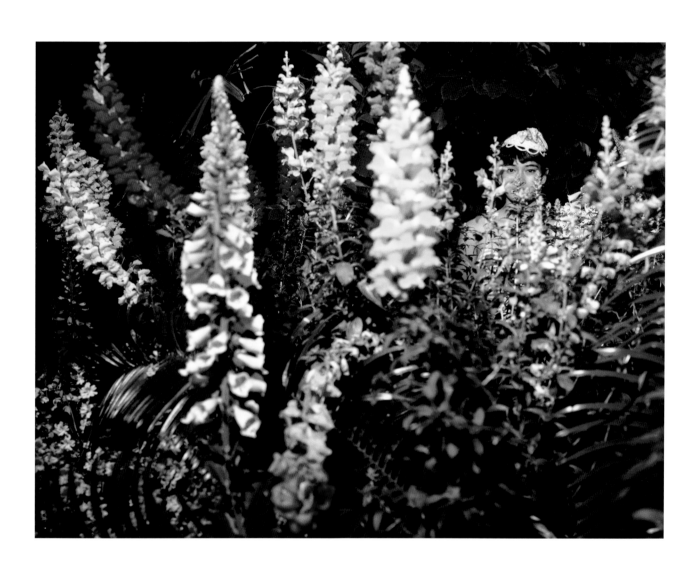

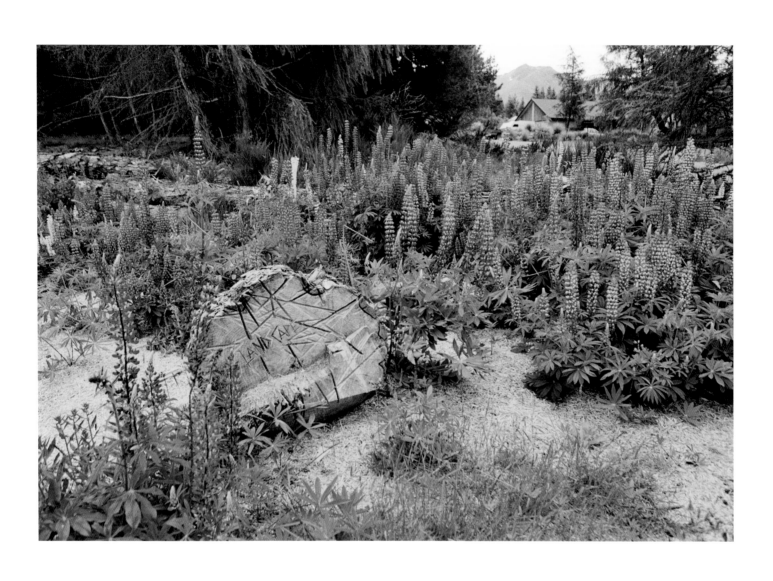

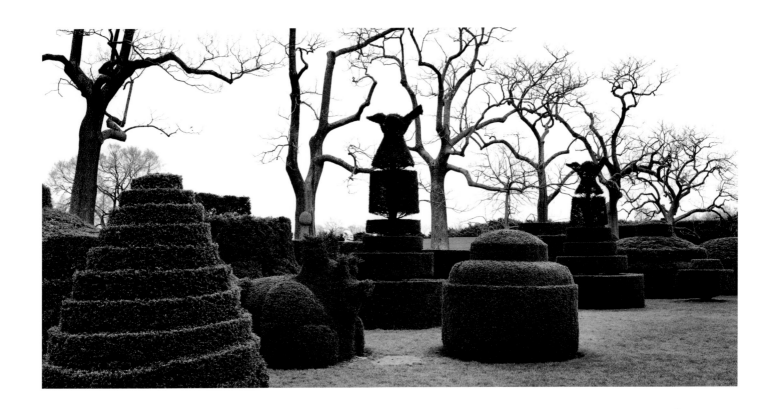

33 | *Bare Trees and Topiary, Longwood Gardens, Kennett Square, Pennsylvania,* 2000

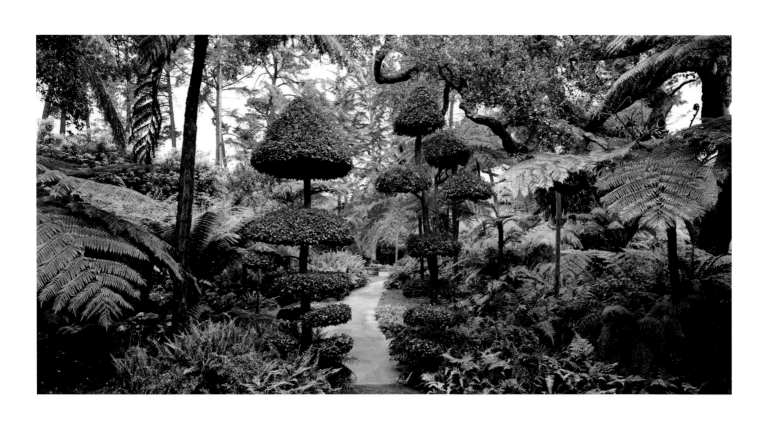

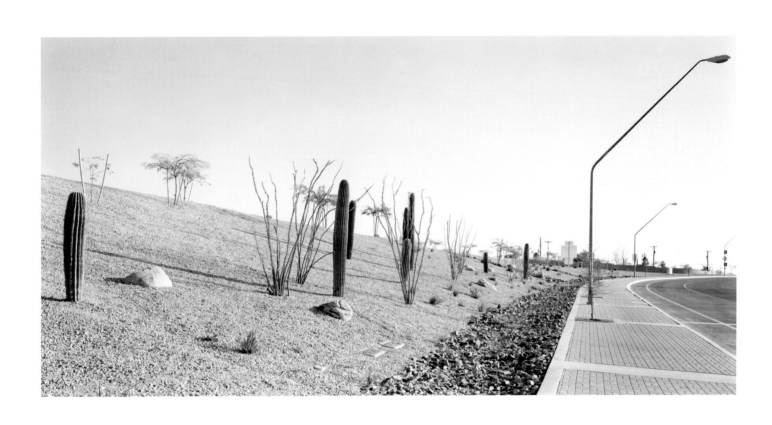

Highway Cactus Planting, Tucson, Arizona, 1999

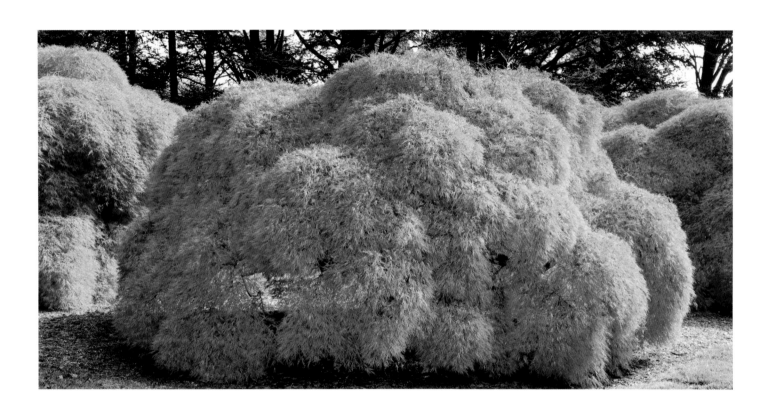

Threadleaf Japanese Maple Tree, Hershey Gardens, Pennsylvania, 1999

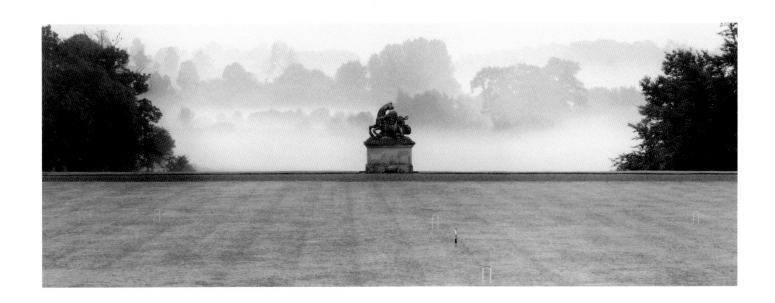

37 | *Bowling Green, Rousham Park, Oxfordshire, England, 1998*

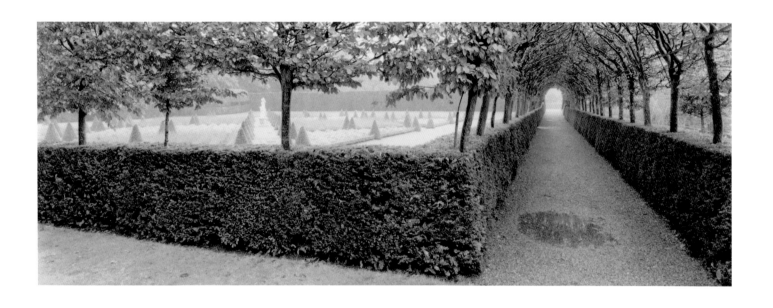

38 | *Hornbeam Arbour, Ham House, England,* 1998

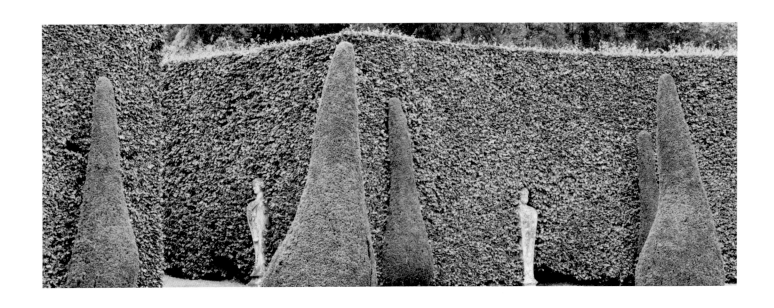

39 | *Stone Figures, Chatsworth, England, 1998*

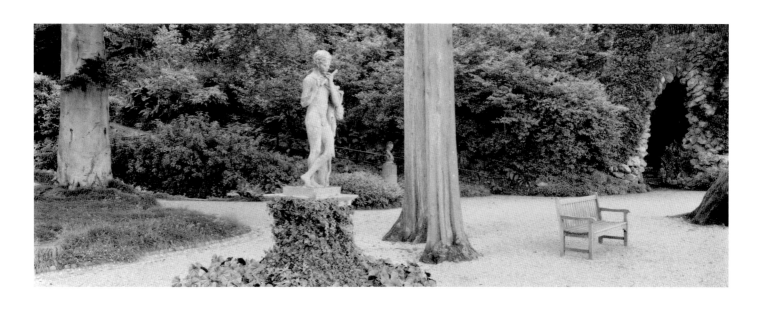

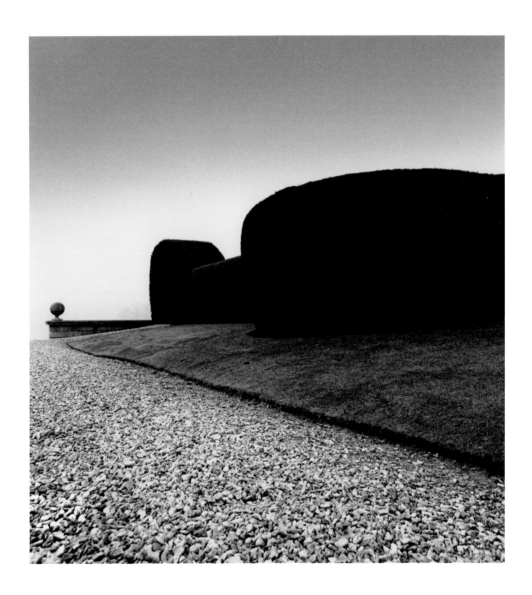

41 | *Bowood Gardens, Study 3, Wiltshire, England, 1987*

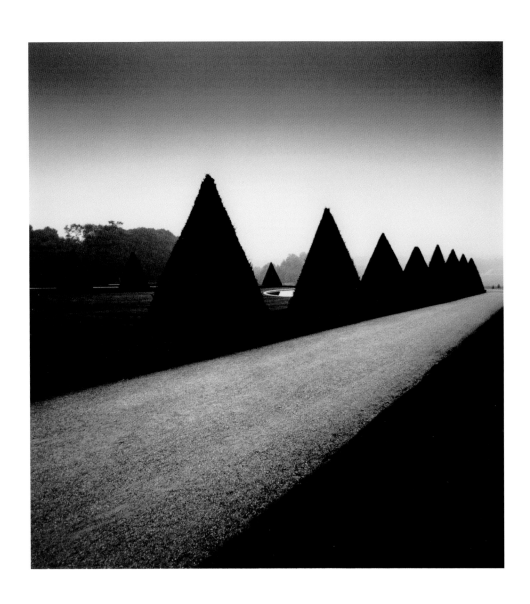

42 | *Homage to Atget, Parc de Sceaux, Paris, France, 1988*

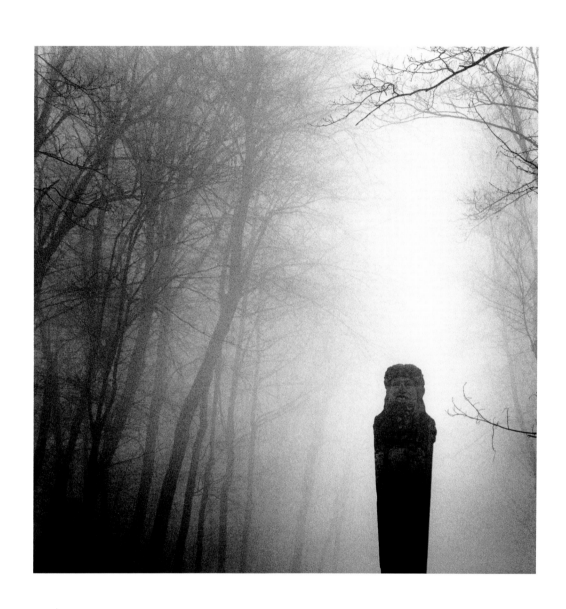

43 | *Herm, Vaux-le-Vicompt, France, 1996*

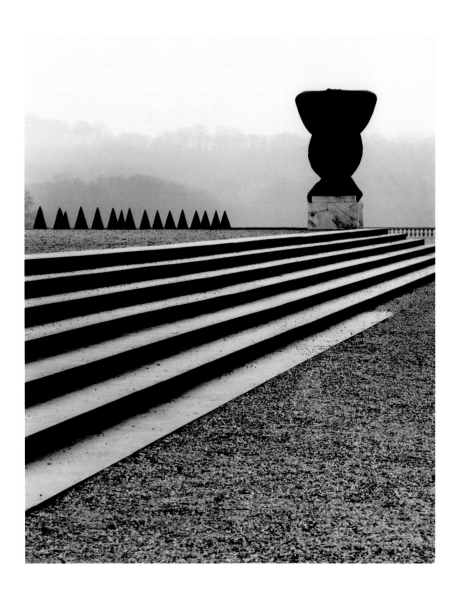

44 | *Covered Urn, Versailles, France,* 1987

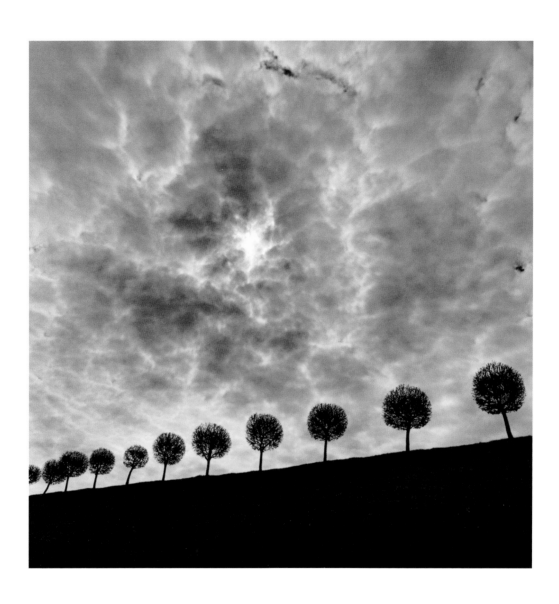

45 | *Ten and a Half Trees, St. Petersburg, Russia,* 2000

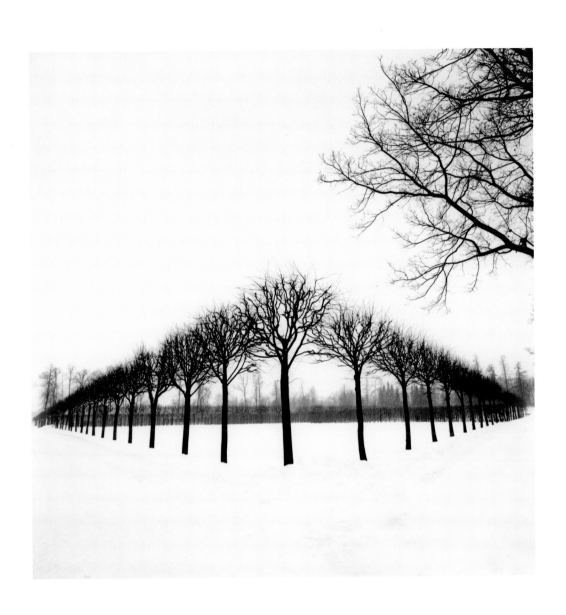

46 | *Perspective of Trees, Tsarskoe Selo, Russia, 1998*

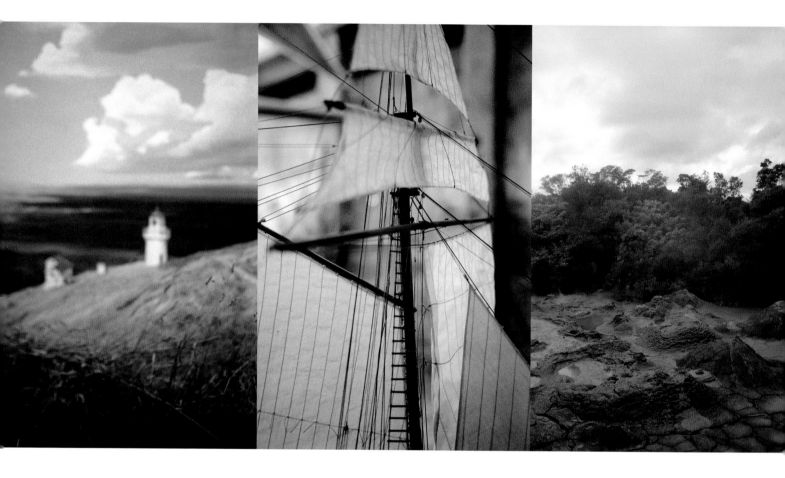

47 | *The Homely: Dunedin (Landscape),* 1999
48 | *The Homely: Auckland (Model),* 1998
49 | *The Homely: Rotorua (Mud),* 1999

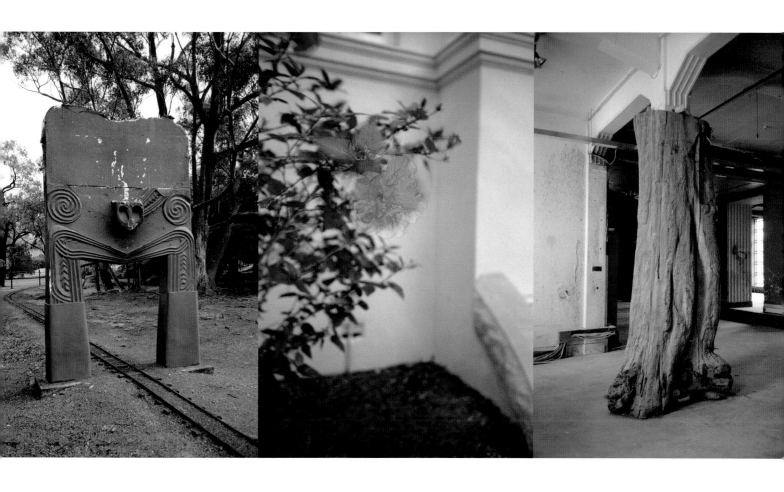

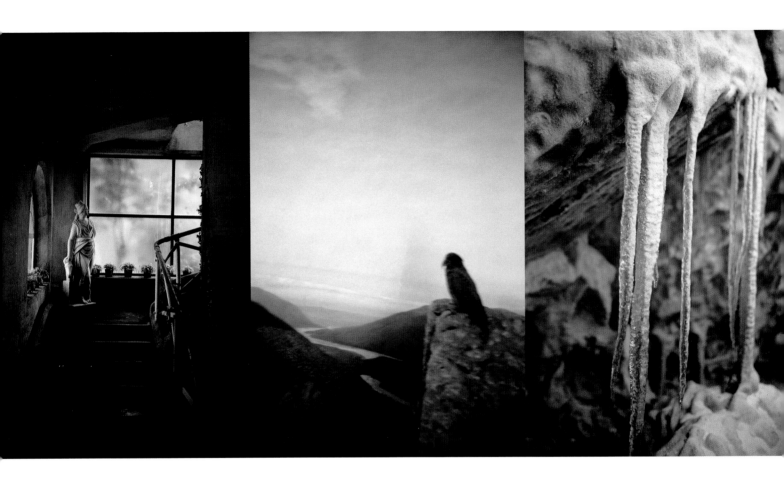

53 | *The Homely: Christchurch (Corridor), 1998*
54 | *The Homely: Christchurch (Museum), 1998*
55 | *The Homely: Christchurch (Icicles), 1998*

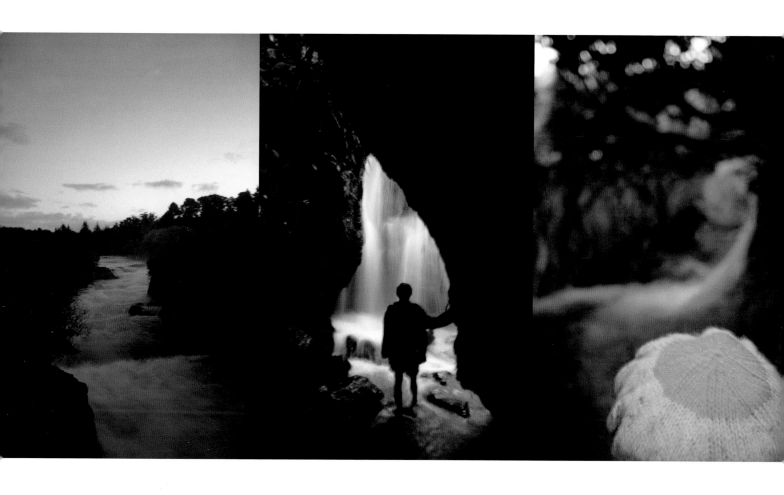

56 | *The Homely: Huka (Falls)*, 1999
57 | *The Homely: Te Wairoa (Falls)*, 1999
58 | *The Homely: Wellington (Path)*, 1999

Despairing of Paradise WE WERE EXPELLED FROM PARADISE, BUT IT WAS NOT DESTROYED. THE EXPULSION FROM PARADISE WAS IN ONE SENSE A PIECE OF GOOD FORTUNE, FOR IF WE HAD NOT BEEN EXPELLED, PARADISE WOULD HAVE HAD TO BE DESTROYED.—*Franz Kafka 1918*

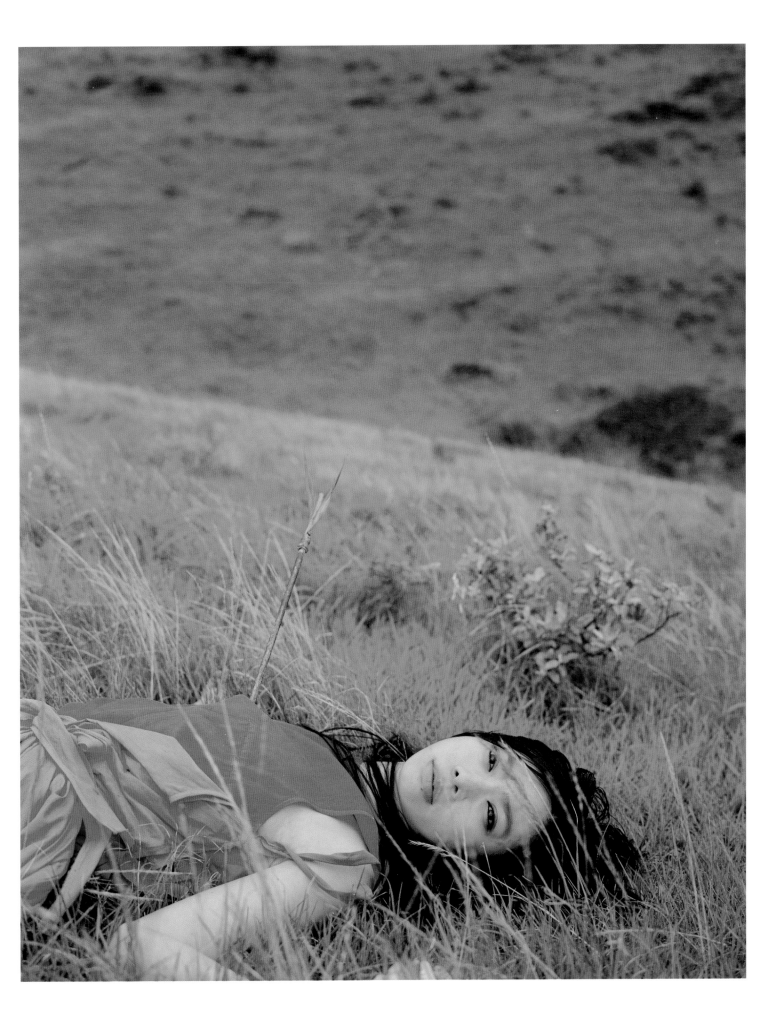

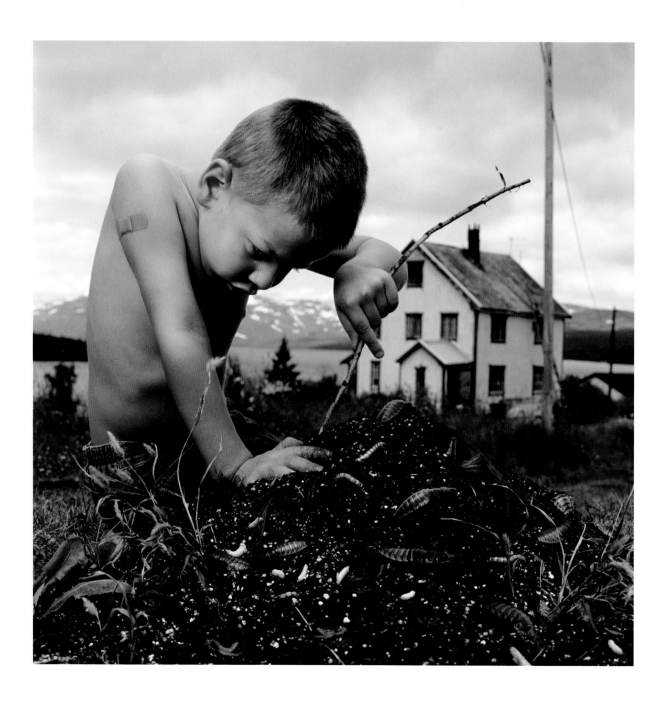

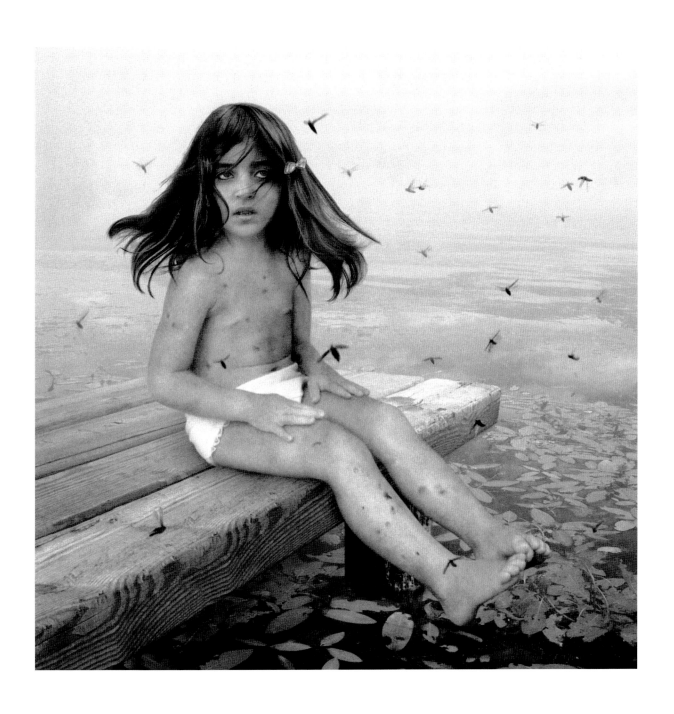

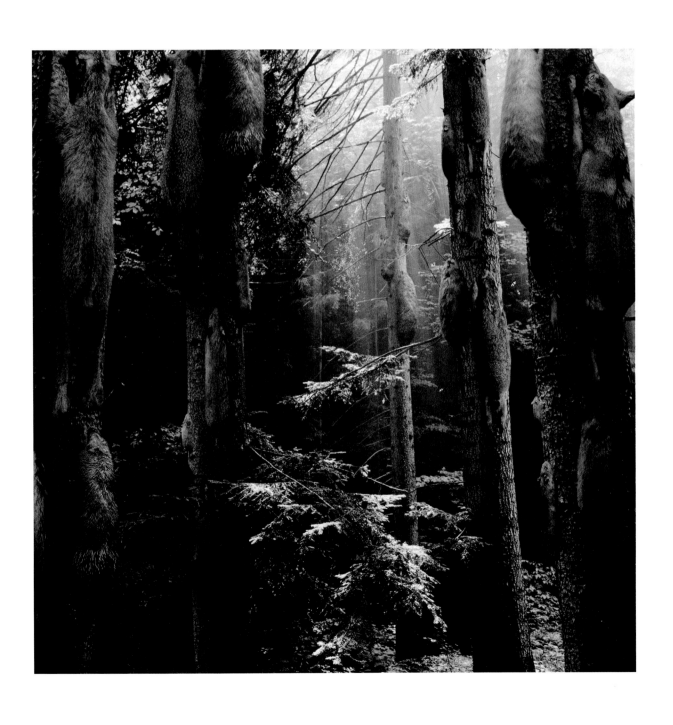

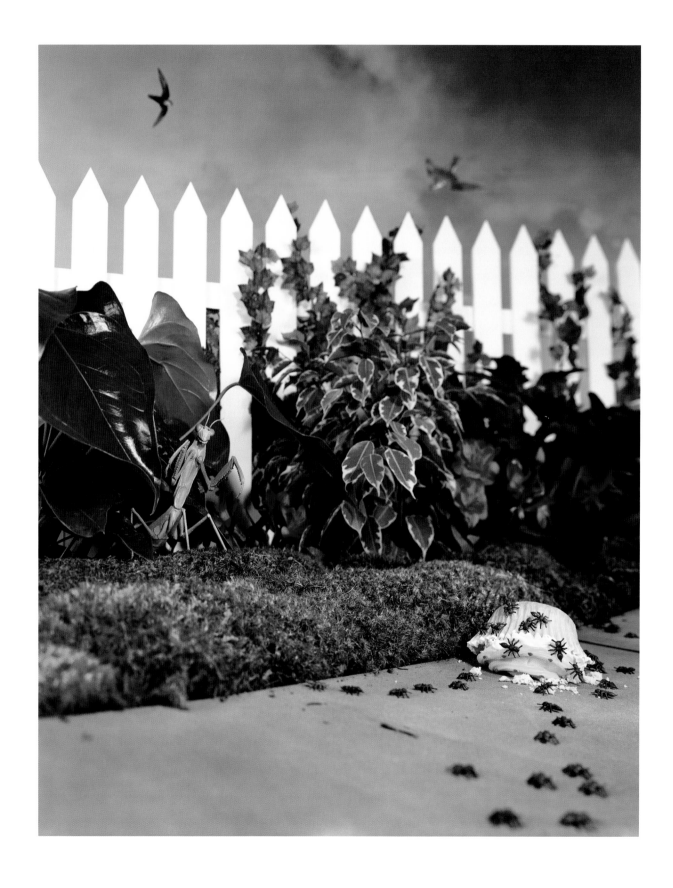

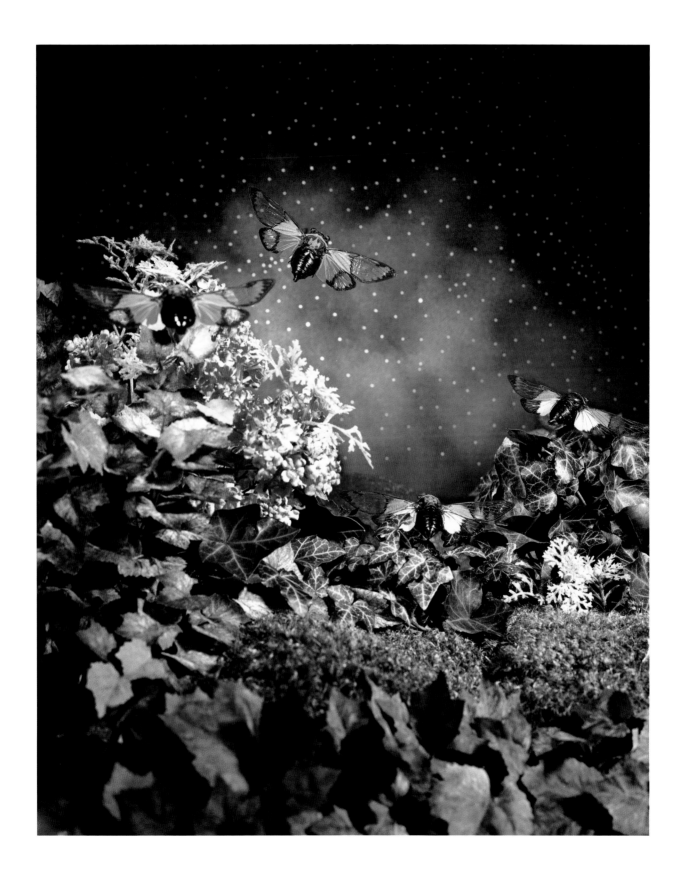

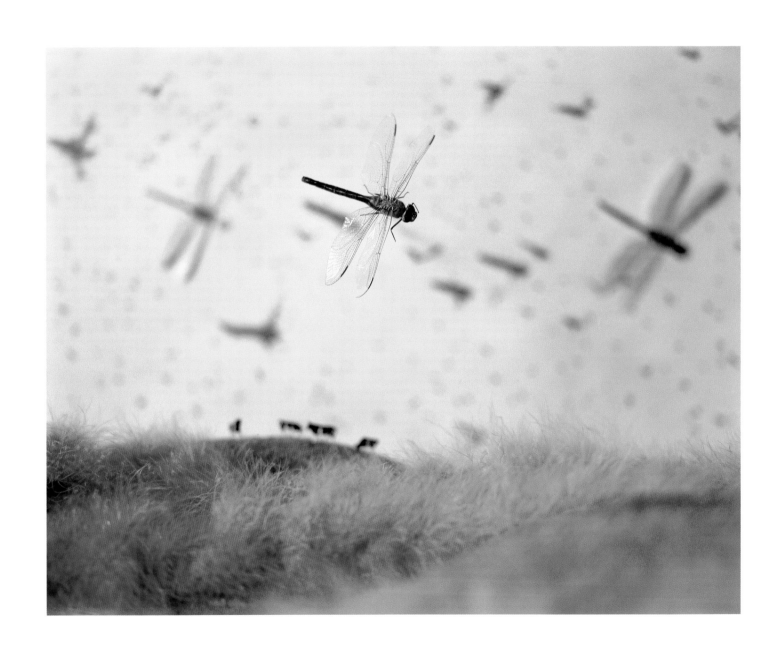

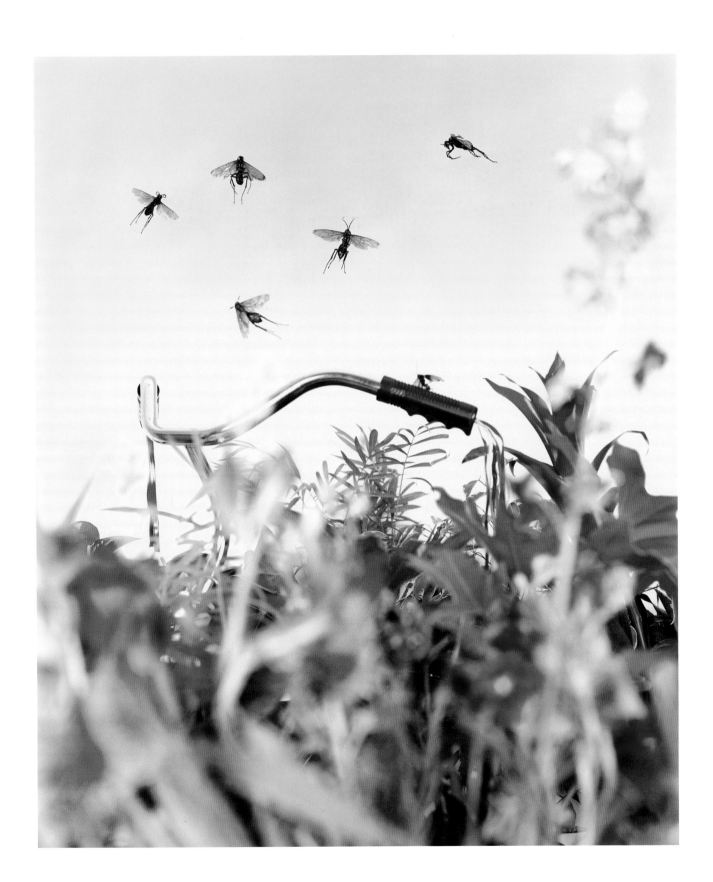

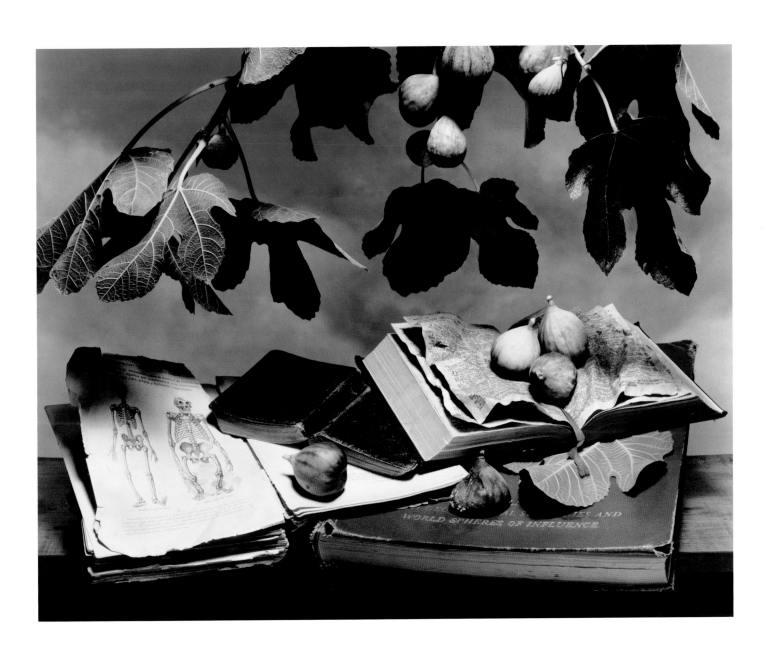

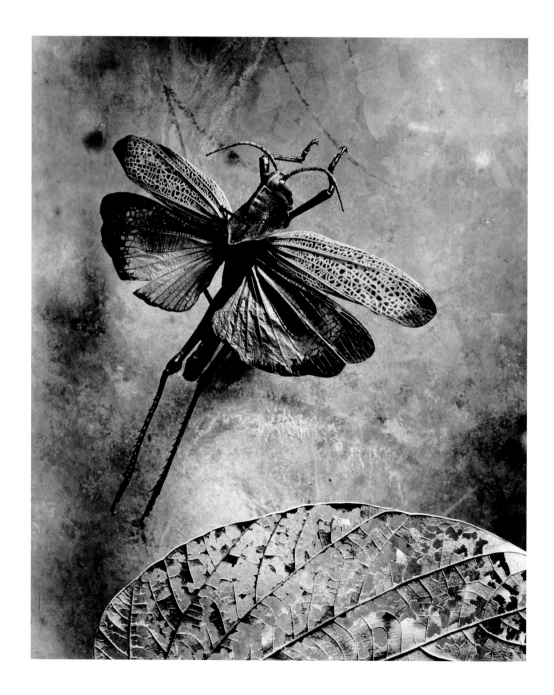

68 | *Othoptera: Lucifer's Apprentice,* 2002
69 | *Harvest, the Fall,* 1992

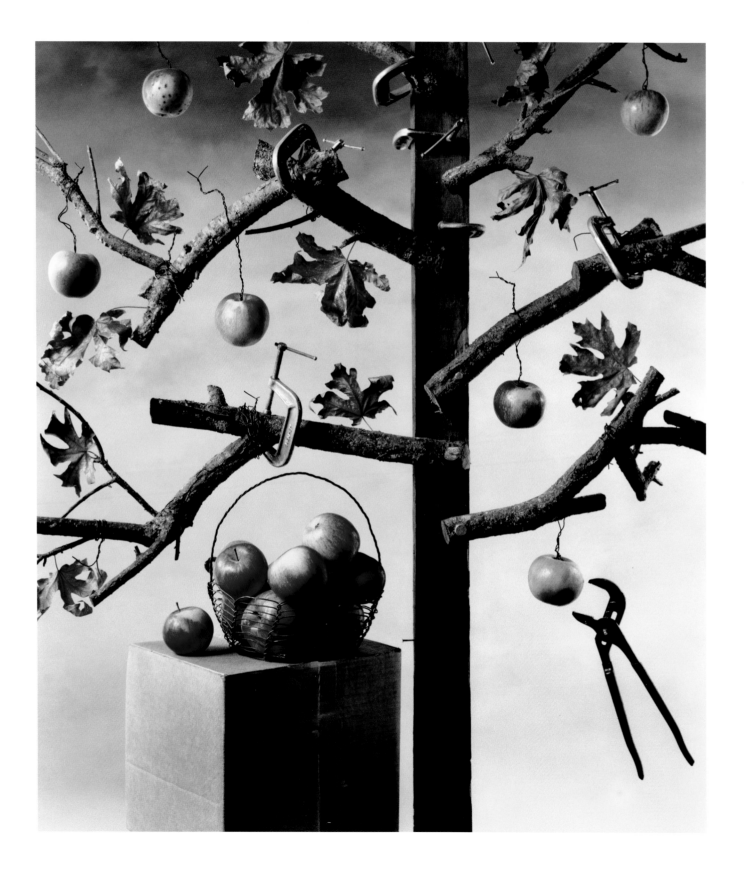

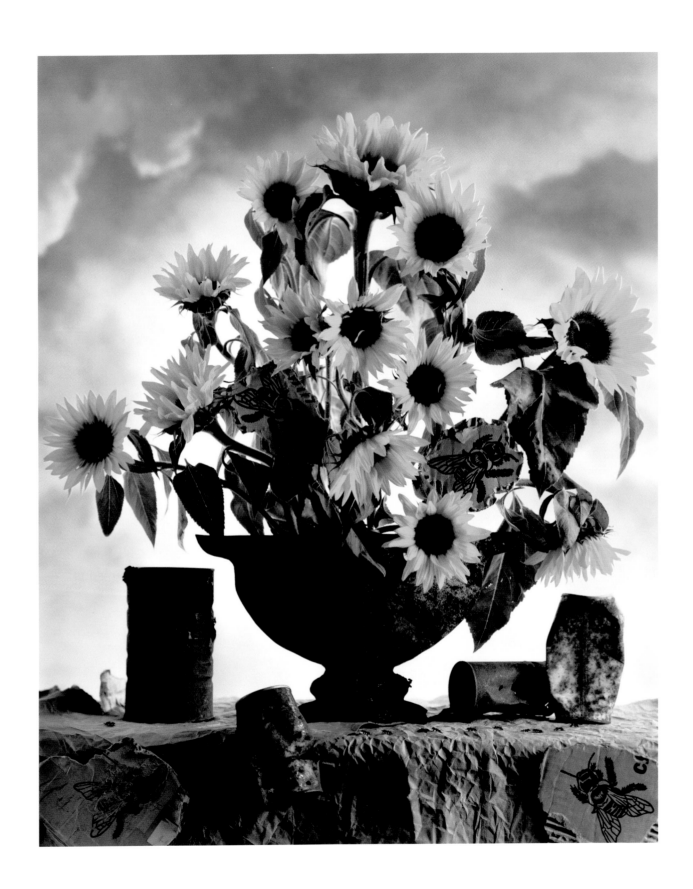

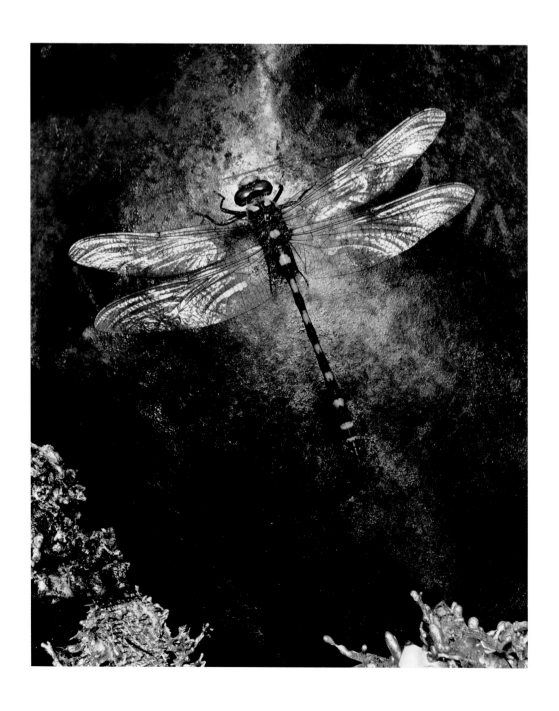

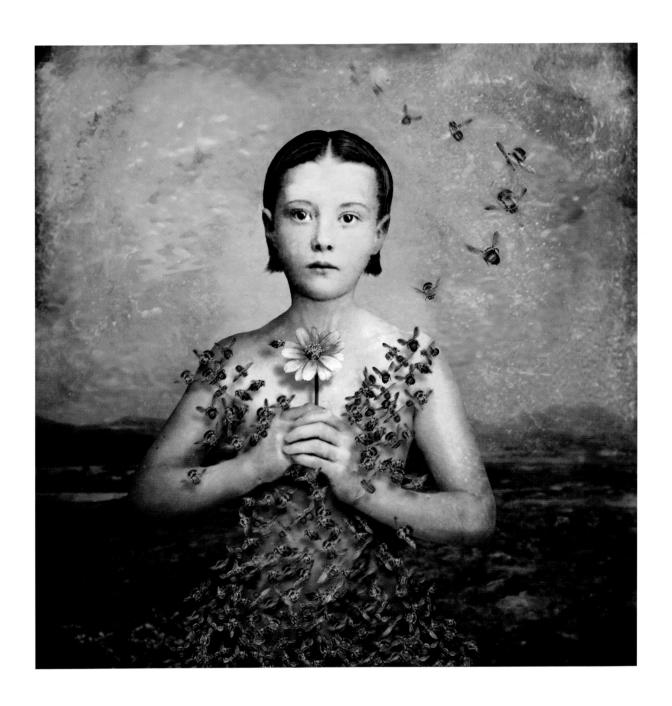

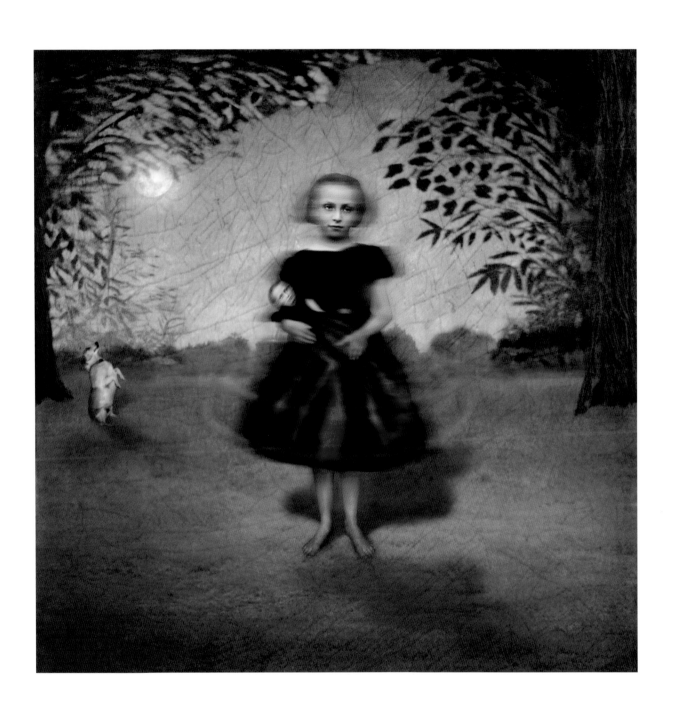

73 | *Abdullah's Prayer,* 2003

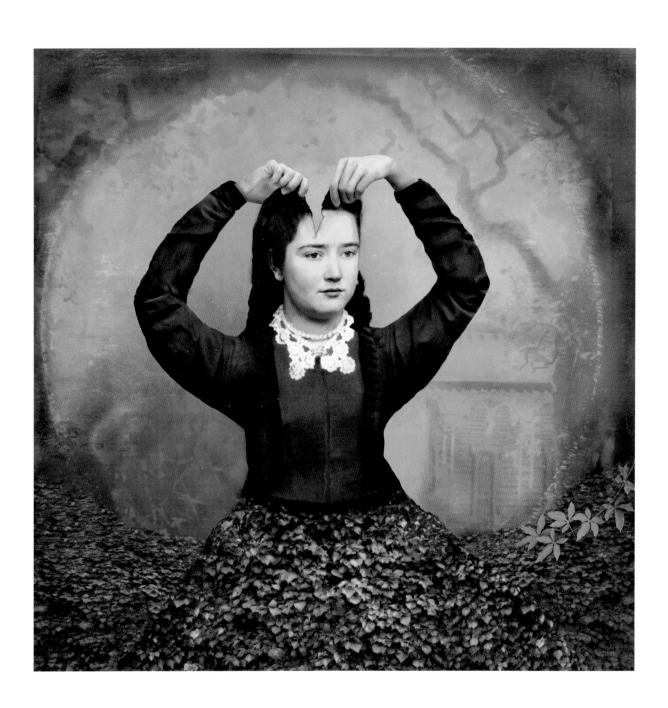

74 | *Southern Gothic*, 2001

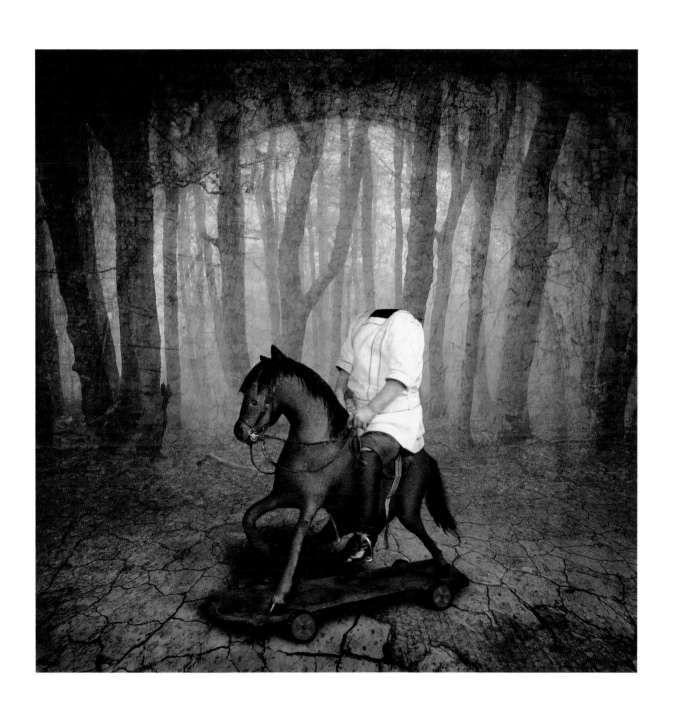

| *Strange Beast,* 2003

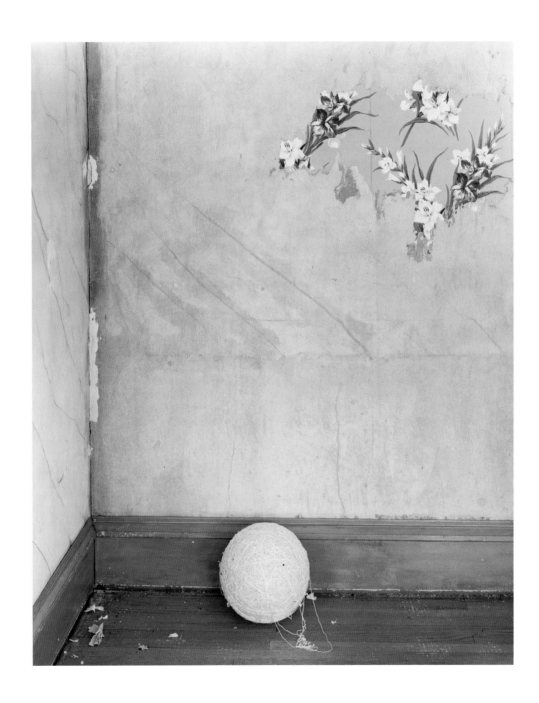

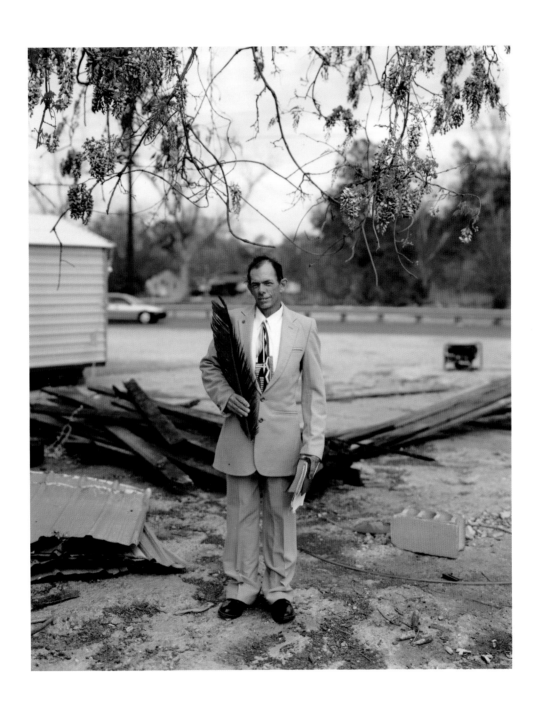

77 | *Patrick, Palm Sunday, Baton Rouge, LA,* 2002

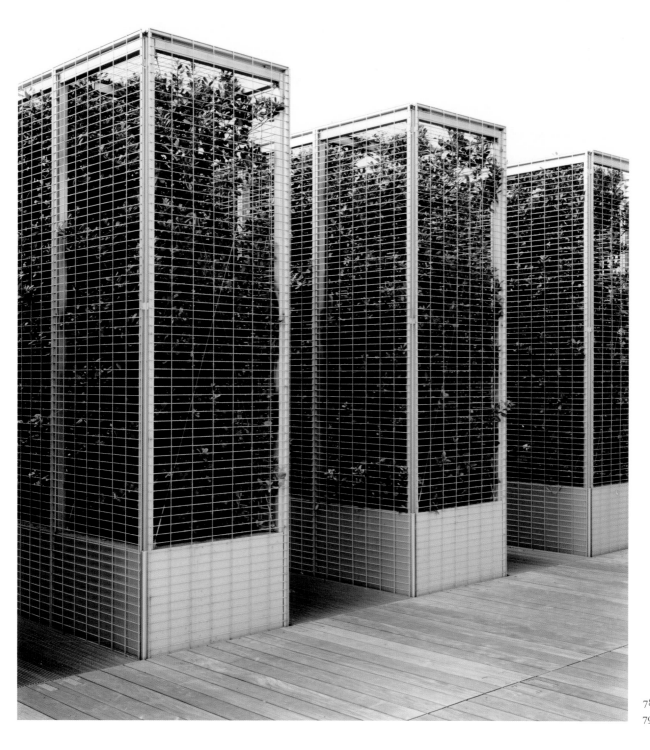

80 | *NASA Space Camp, Kita-Kyushu, Japan,* from *Wonderland,* c.1999

81 | *Autostadt, Wolfsburg, Germany,* from *Wonderland,* c.1999

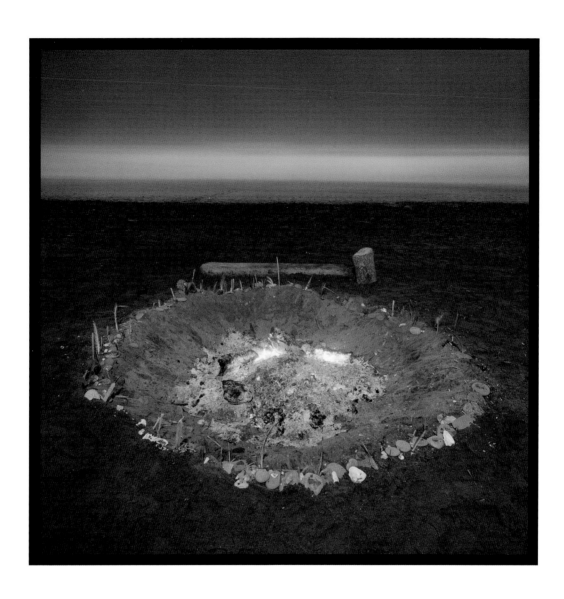

83 | *Solstice Fire Ring, Ocean Beach, San Francisco,* 2004

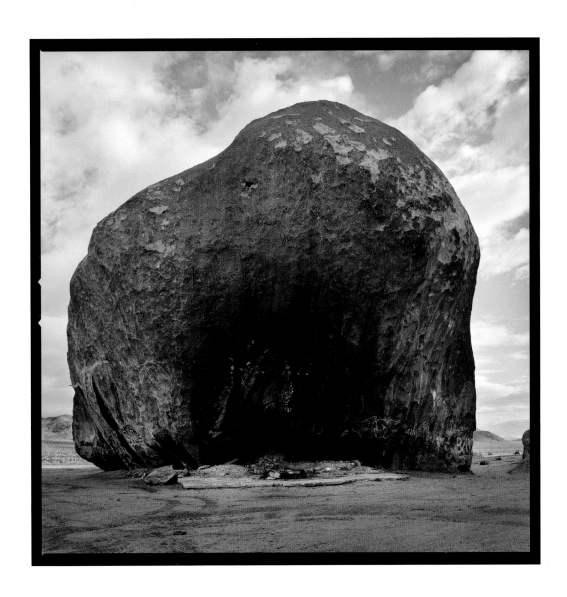

84 | *Giant Rock, San Bernardino County,* 2005

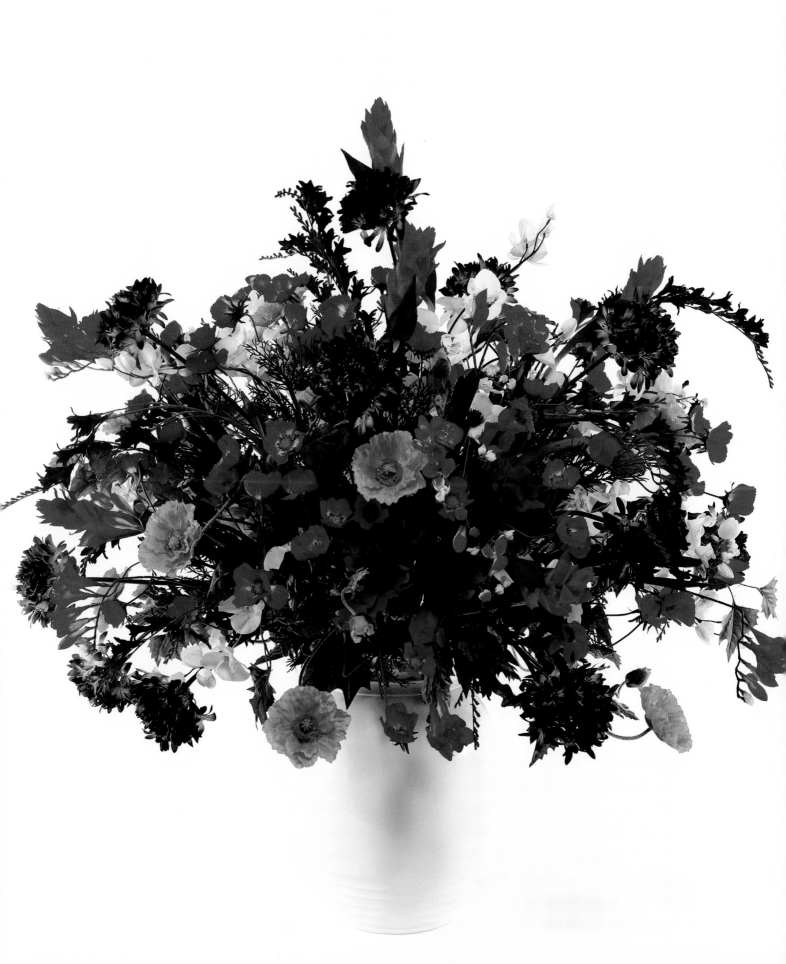

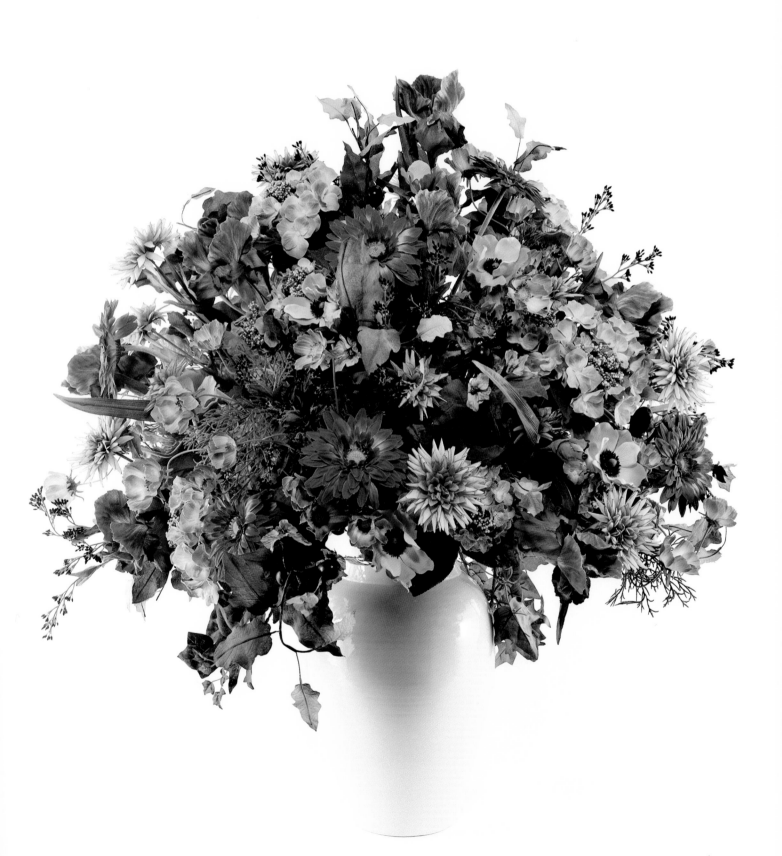

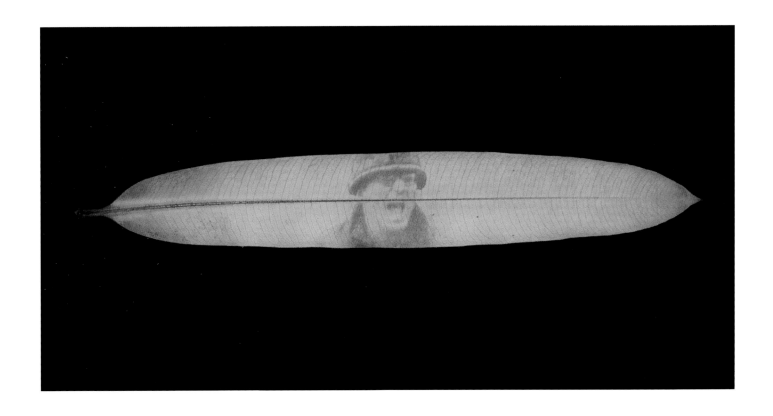

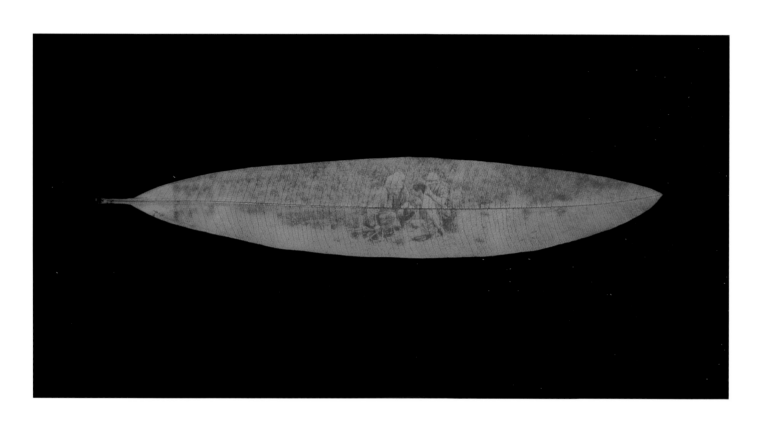

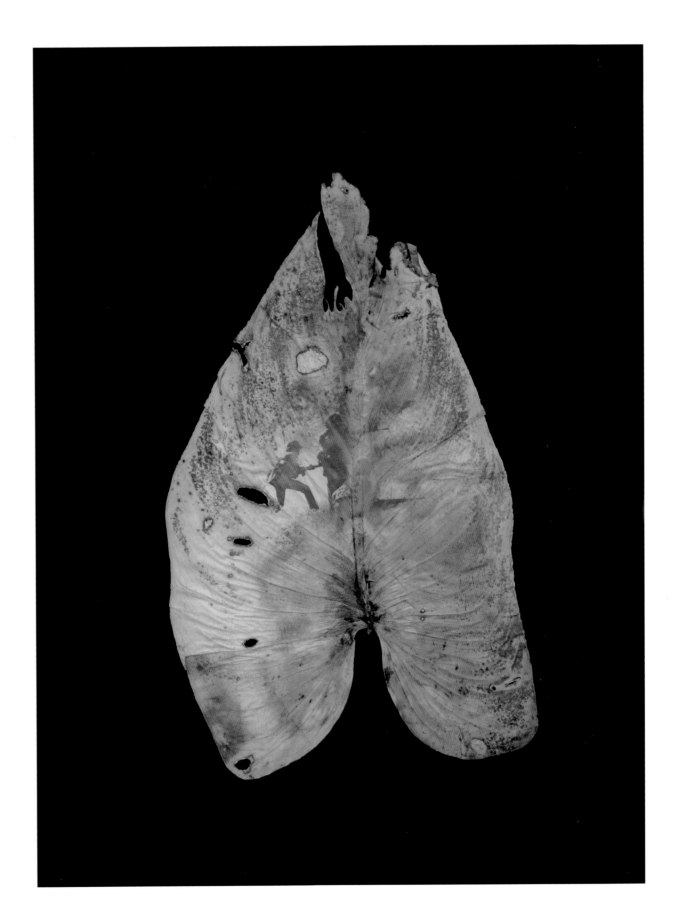

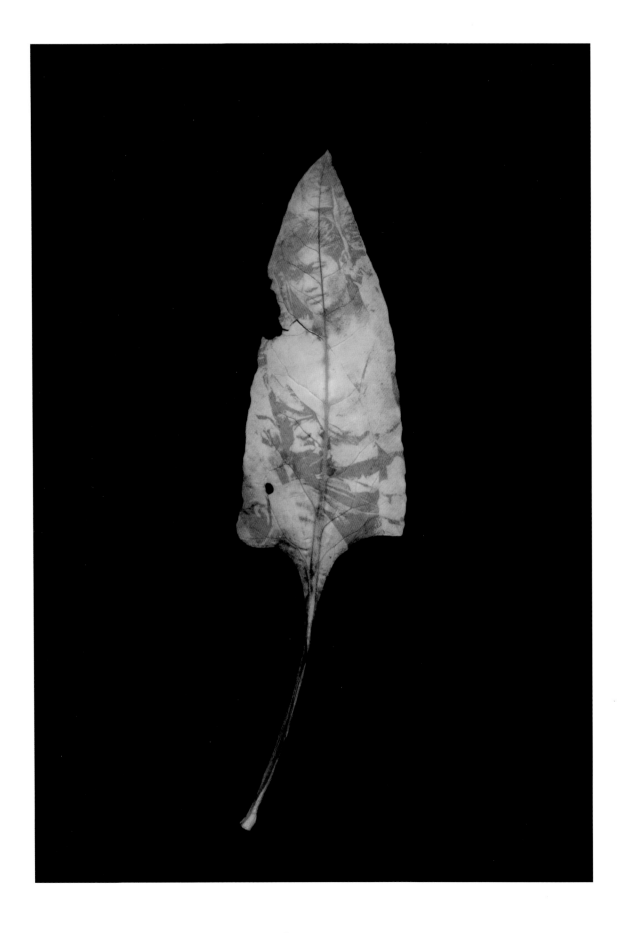

92 | *Cloned Plants (Tissue Culture) in Medium #1, Auckland, 1996*

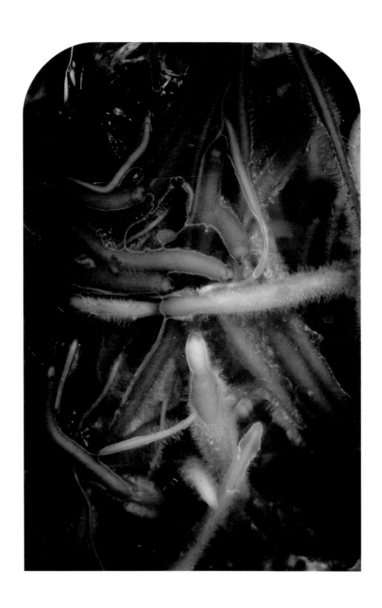

93 | *Cloned Plants (Tissue Culture) in Medium #2, Auckland, 1996*

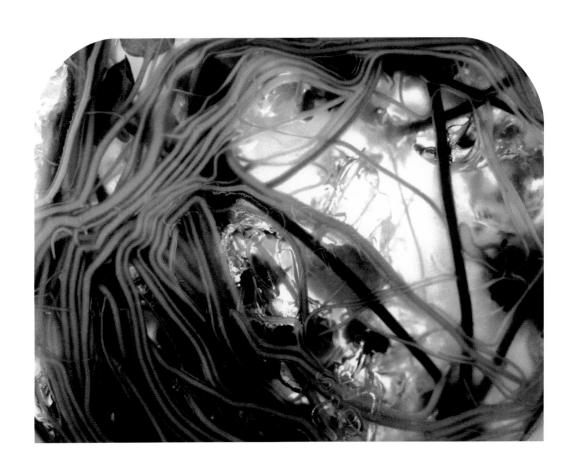

94 | *Cloned Plants (Tissue Culture) in Medium #3, Auckland, 1996*

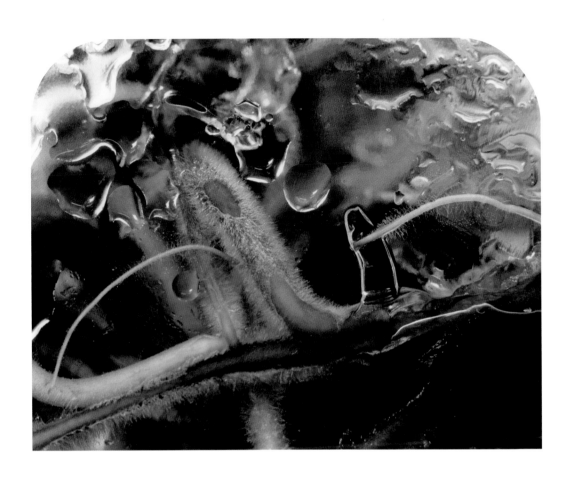

| *Cloned Plants (Tissue Culture) in Medium #4, Auckland, 1996*

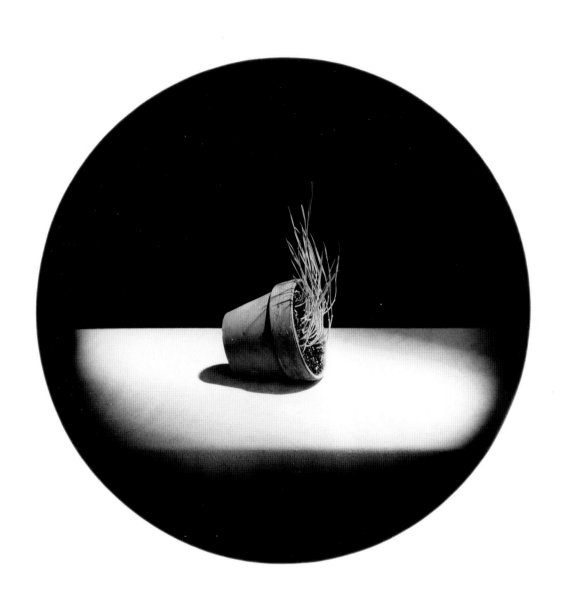

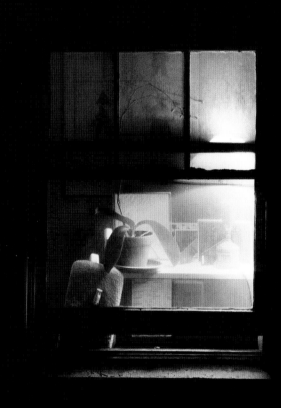

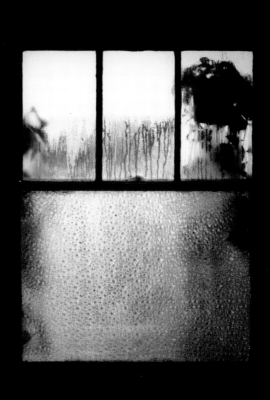

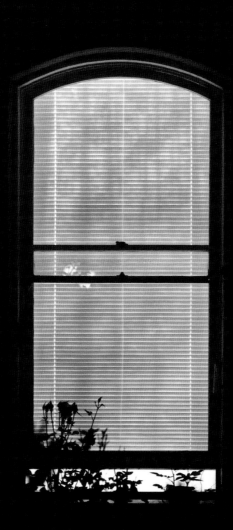

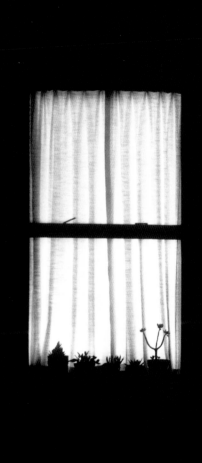

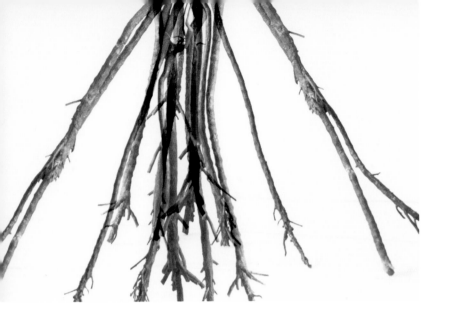

Paradise Anew

UNTO YOU IS PARADISE OPENED.

—2 Esdras VII. 52

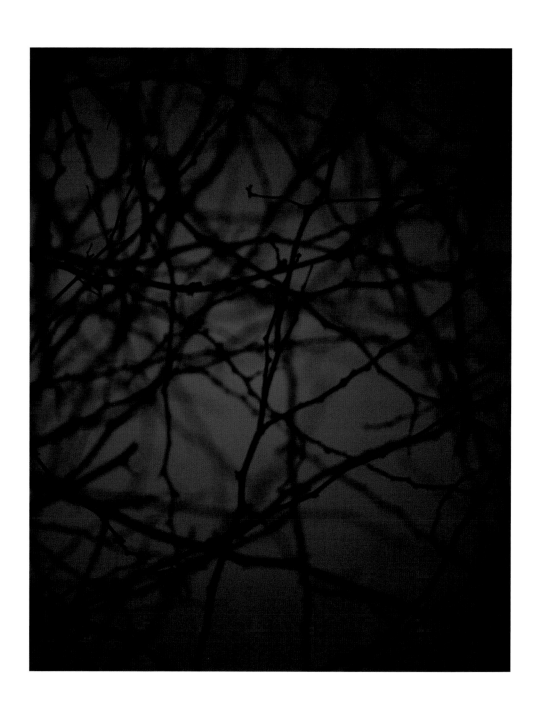

103 | *Dusk #3*, 2003
104 | *Dusk #11*, 2003

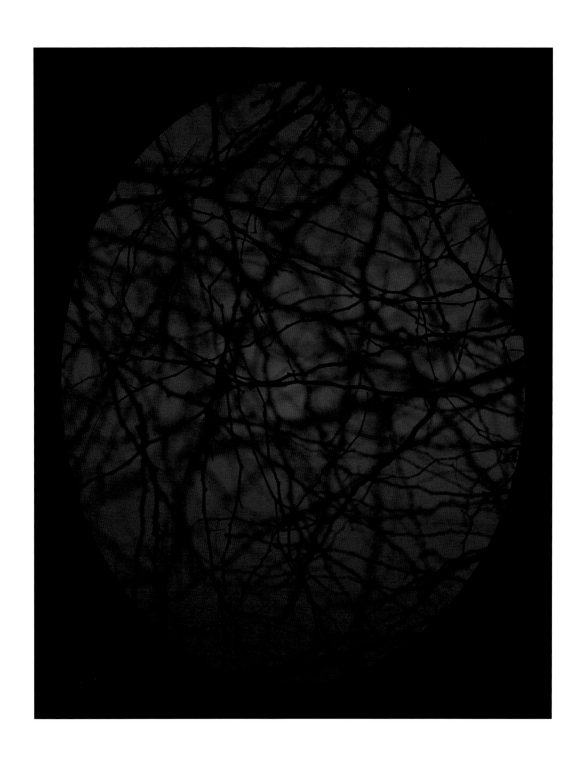

105 | *Dusk #33,* 2003

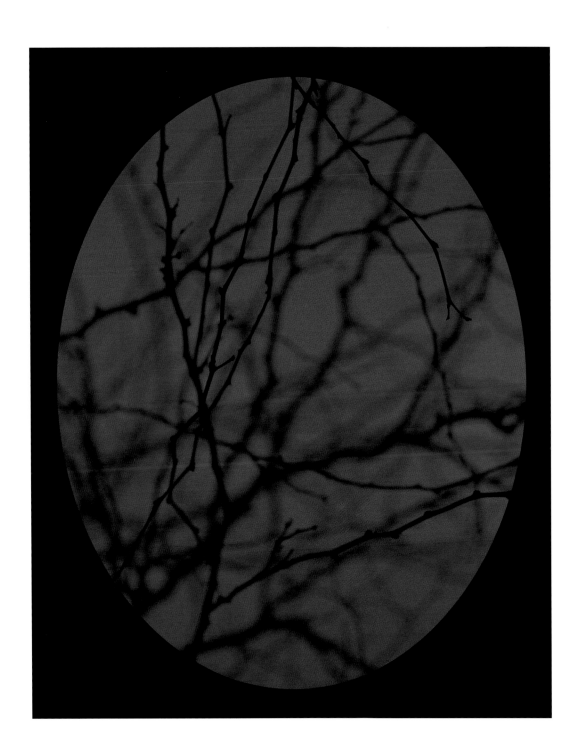

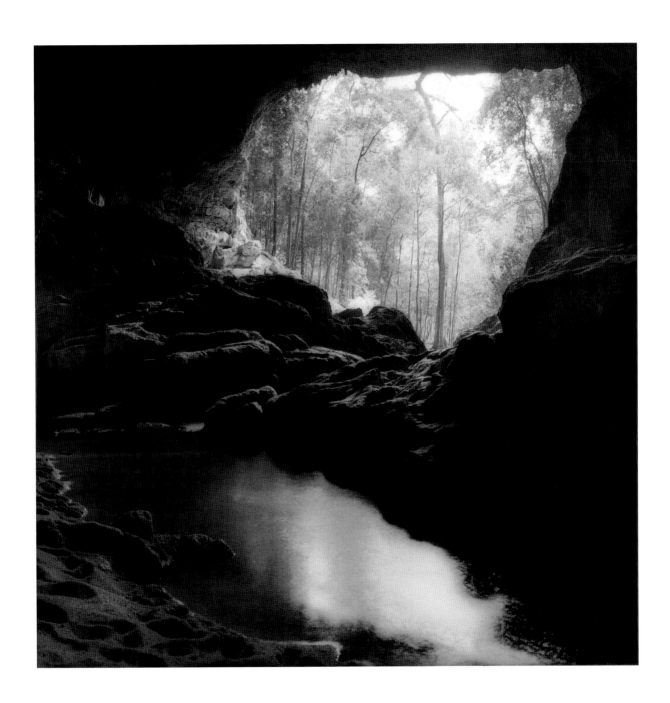

107 | *Oasis,* 1999

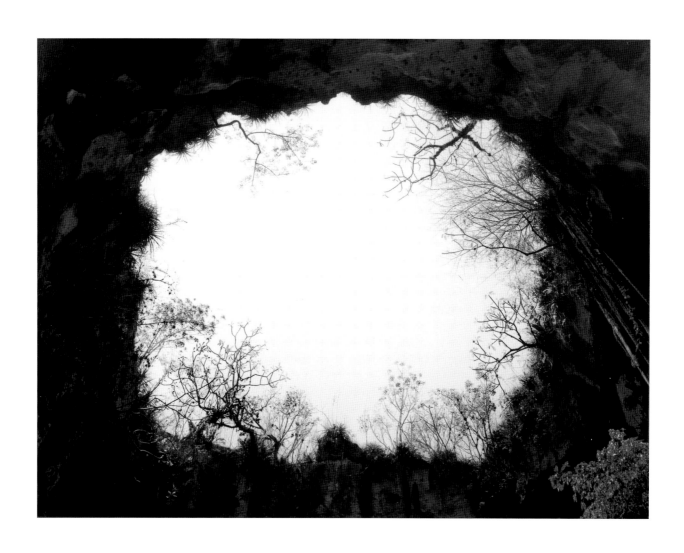

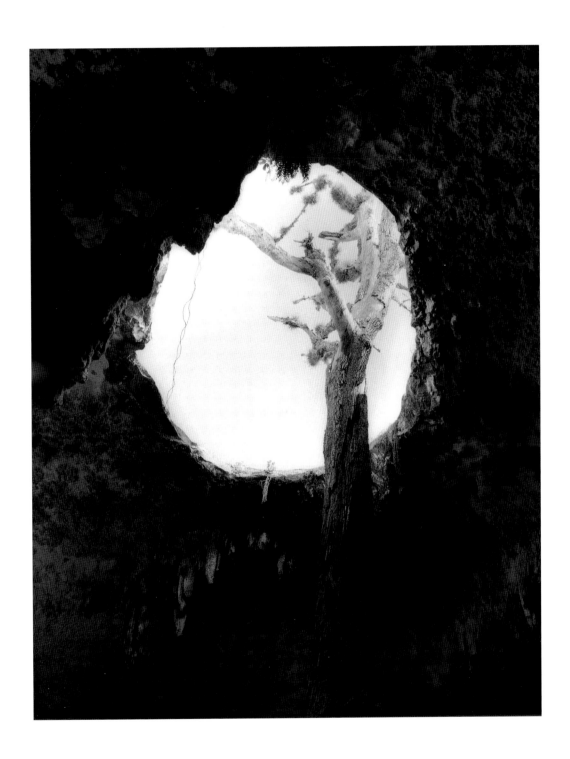

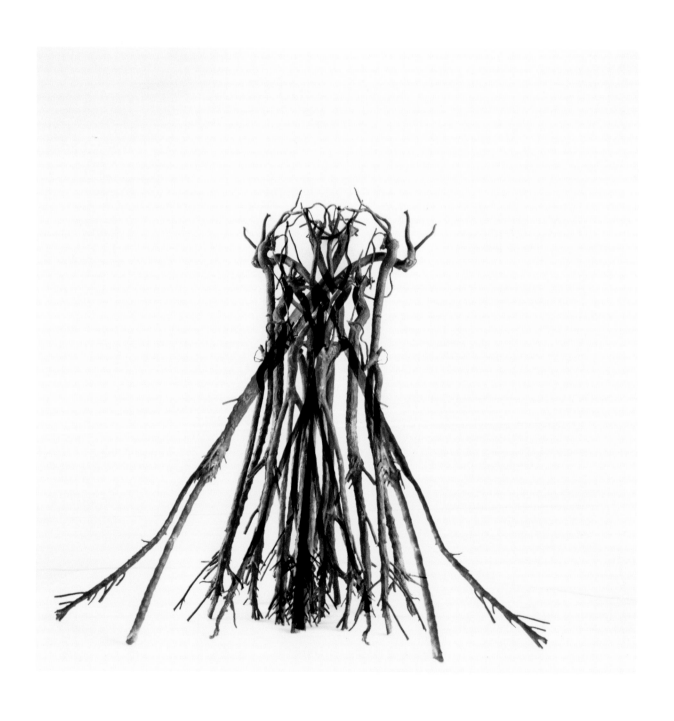

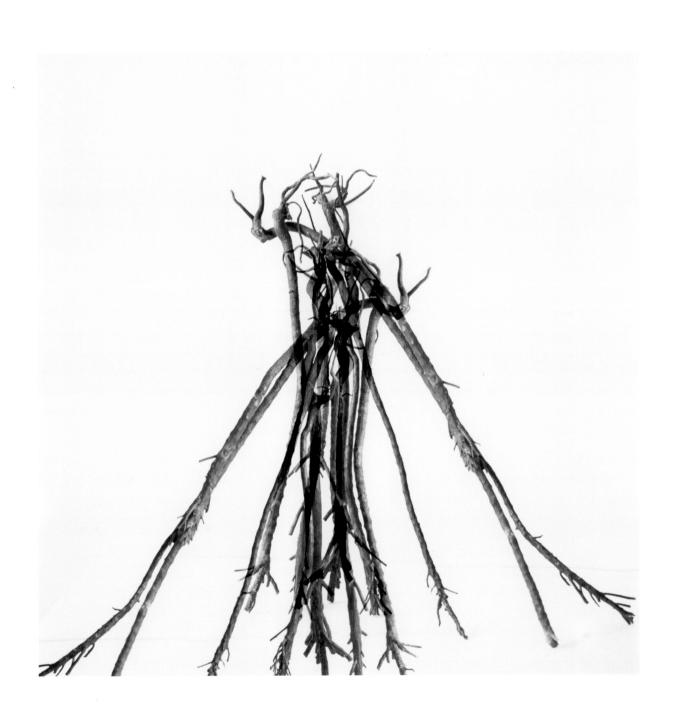

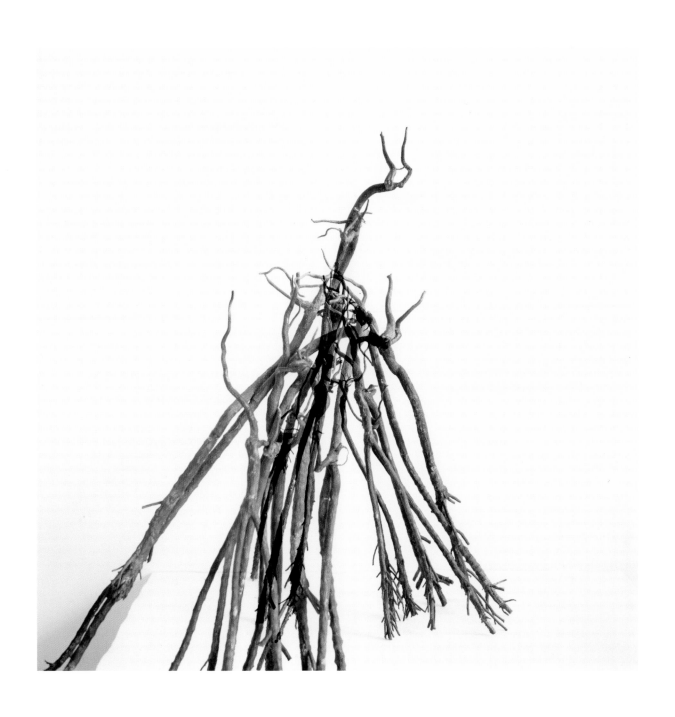

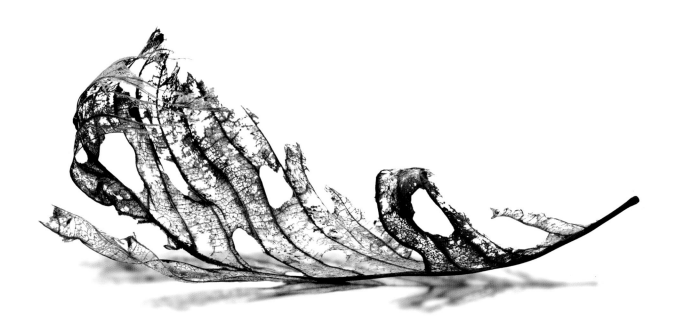

113 | *Black Pulse #17 (Lambda)*, 2000-05

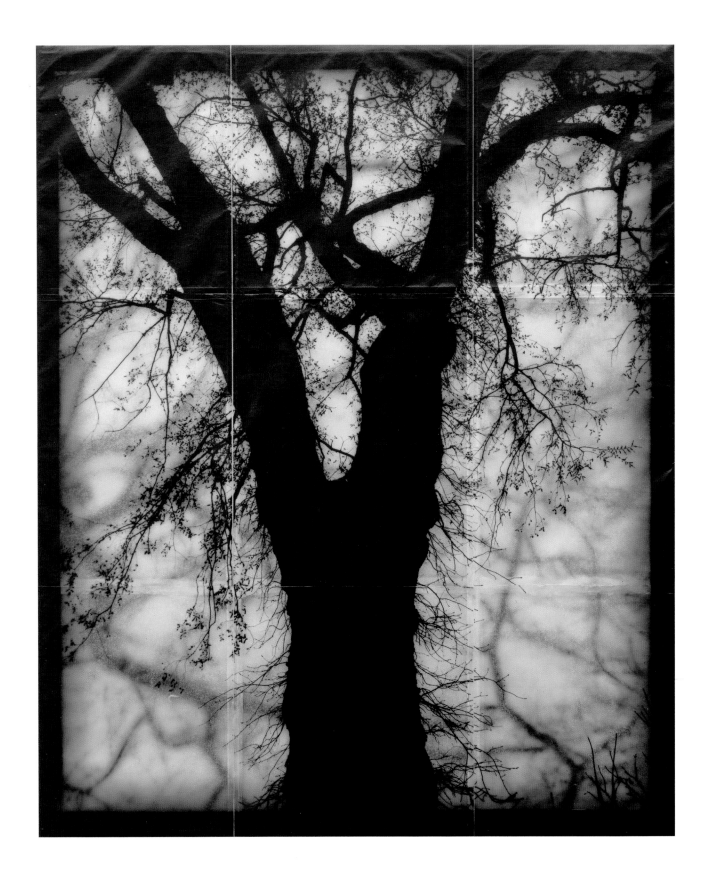

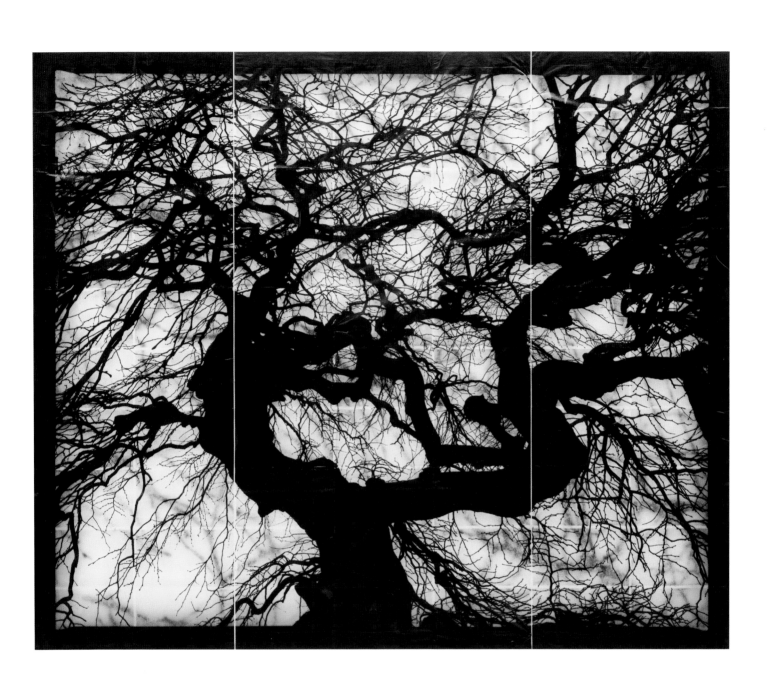

114 | *Structure of Thought #2,* 2001-05
115 | *Structure of Thought #15,* 2001-05

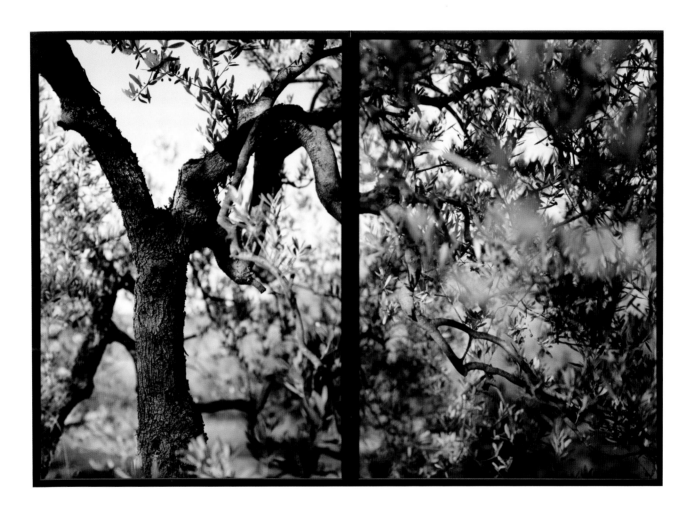

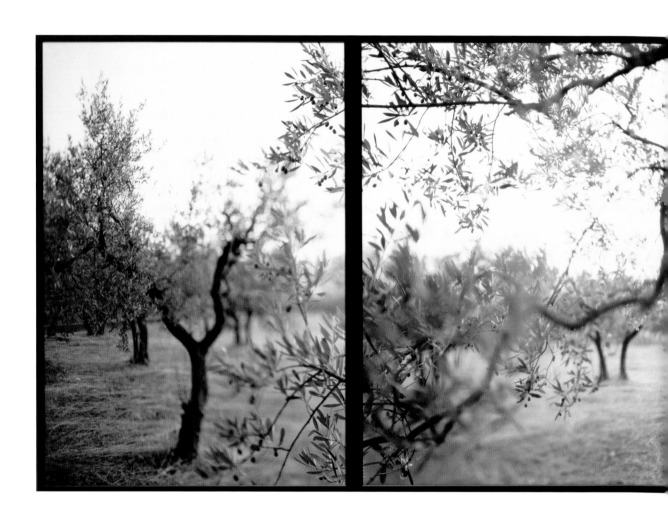

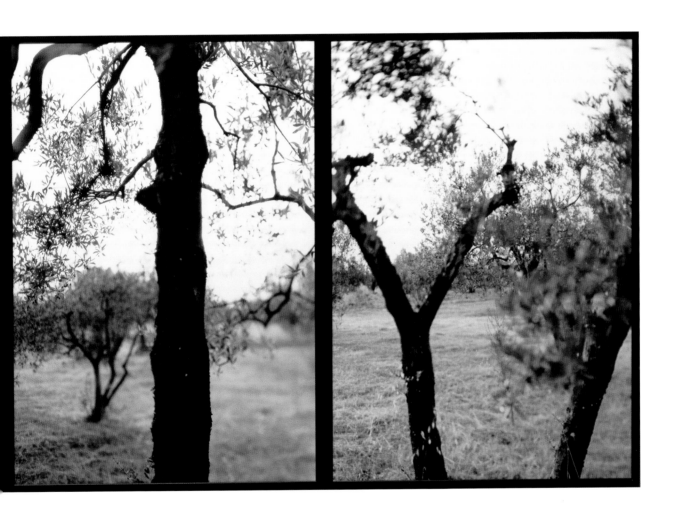

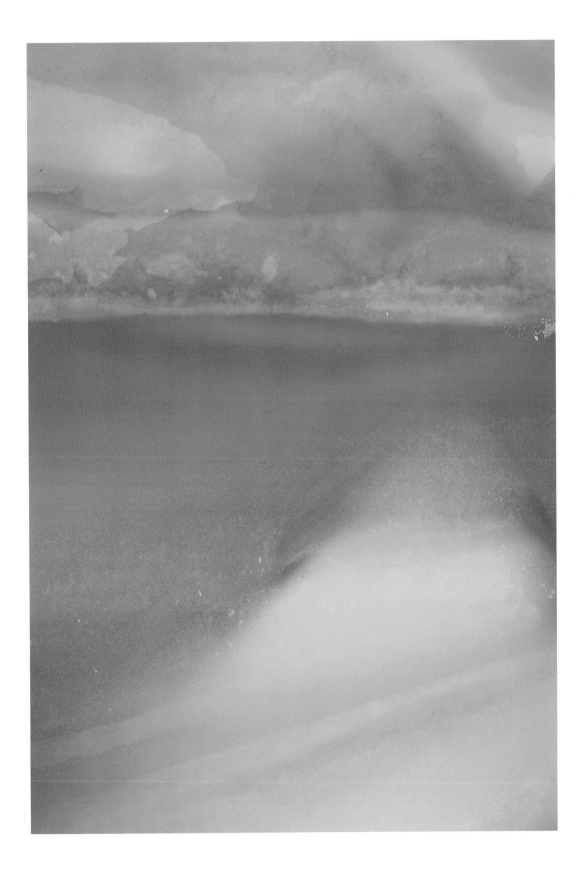

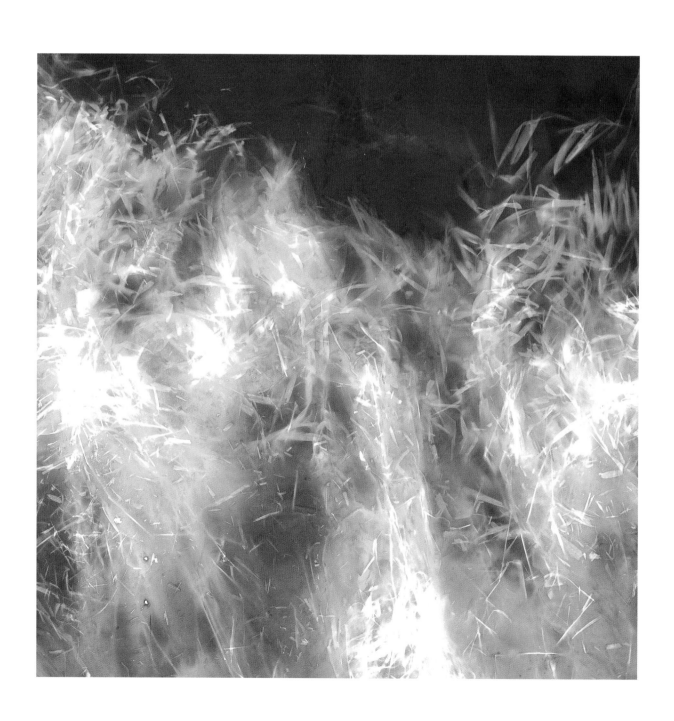

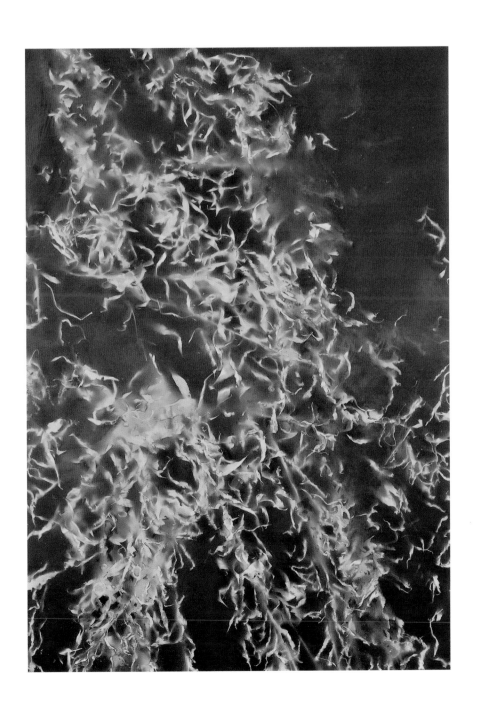

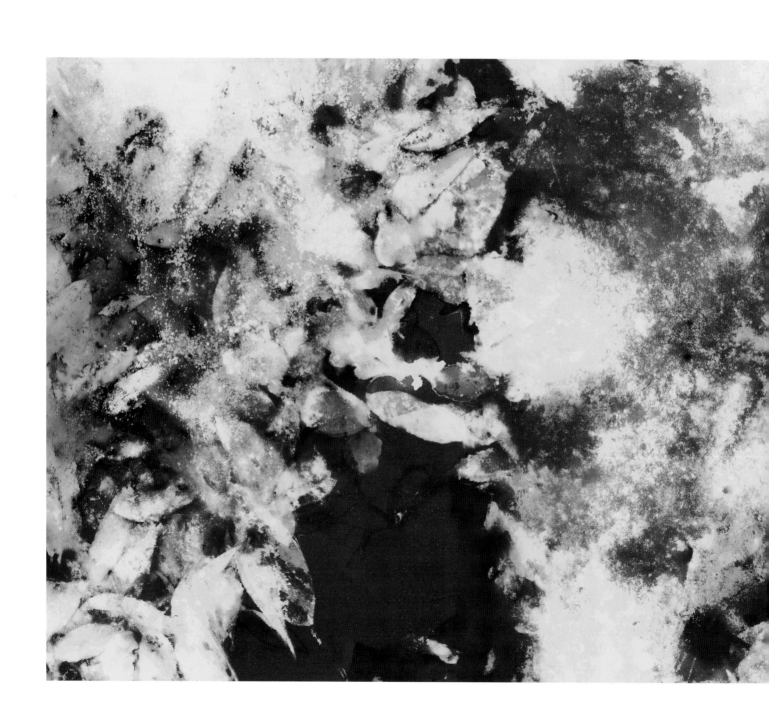

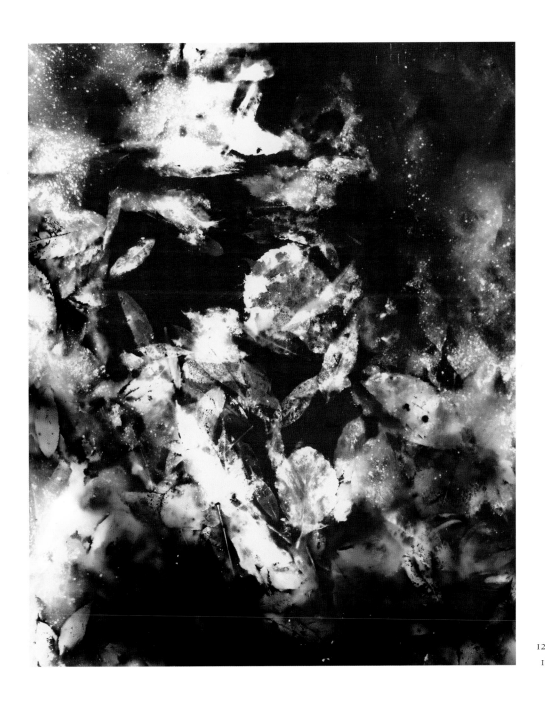

121 | *Lagoon—Water Level,* 22.10.–5.11.2000
122 | *Lagoon—Water Level,* 12.–22.11.2000

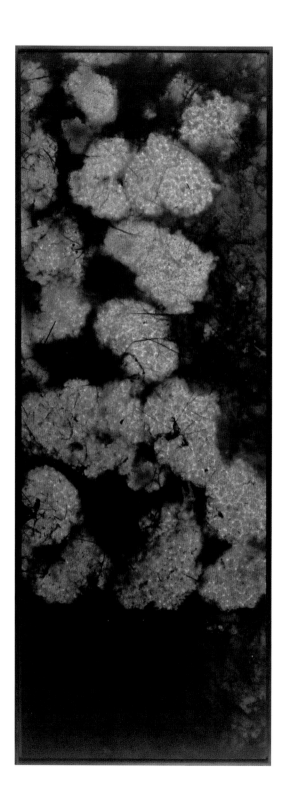

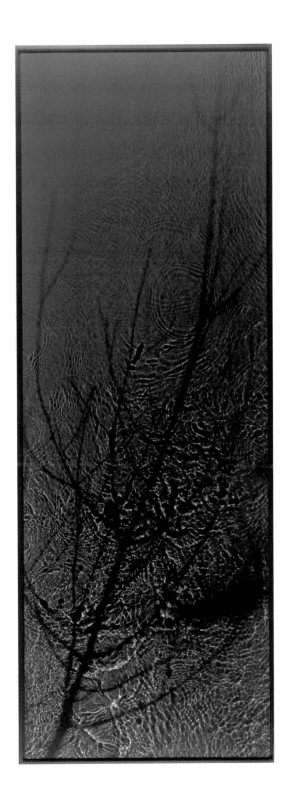

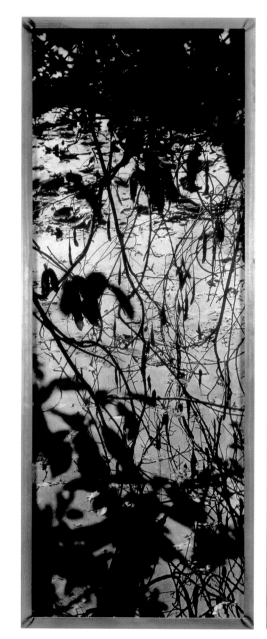
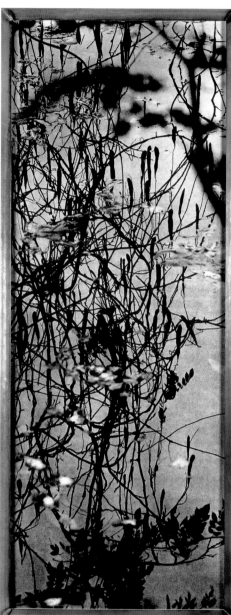

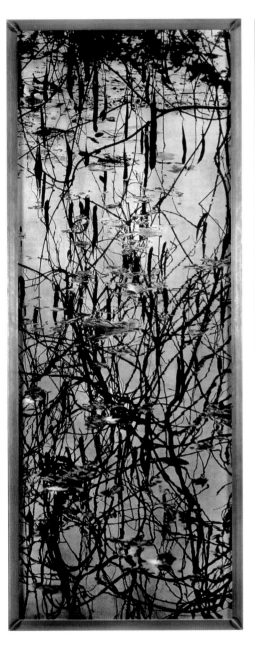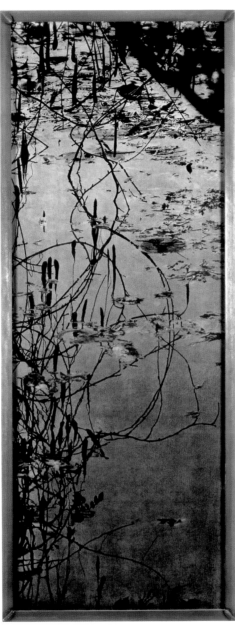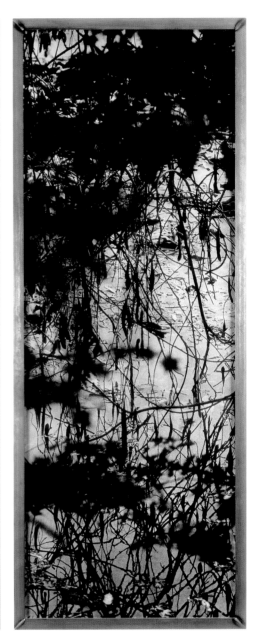

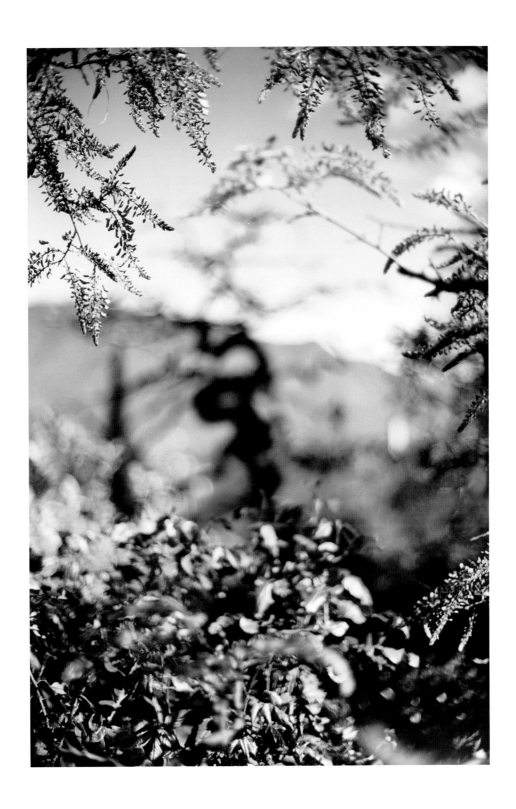

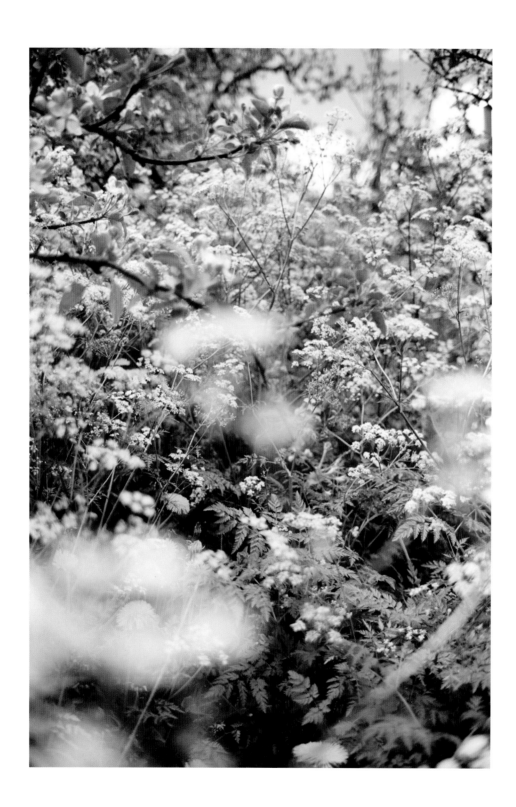

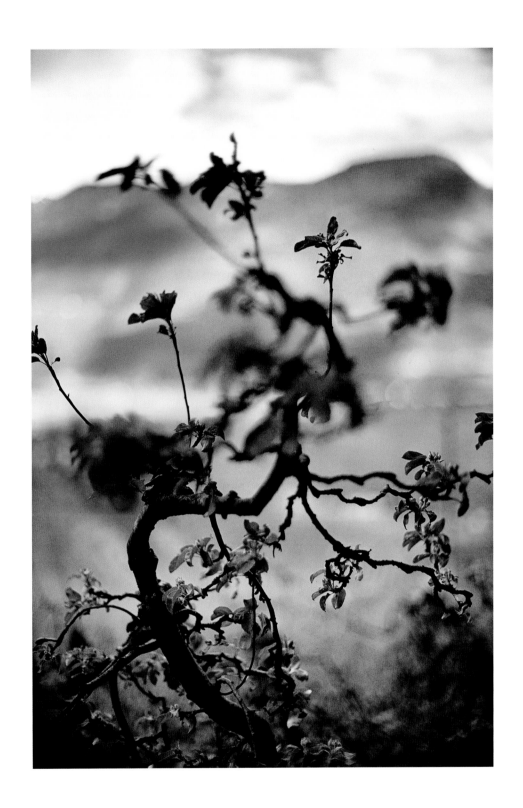

129 | *Lana Series #66, 1998-2001*

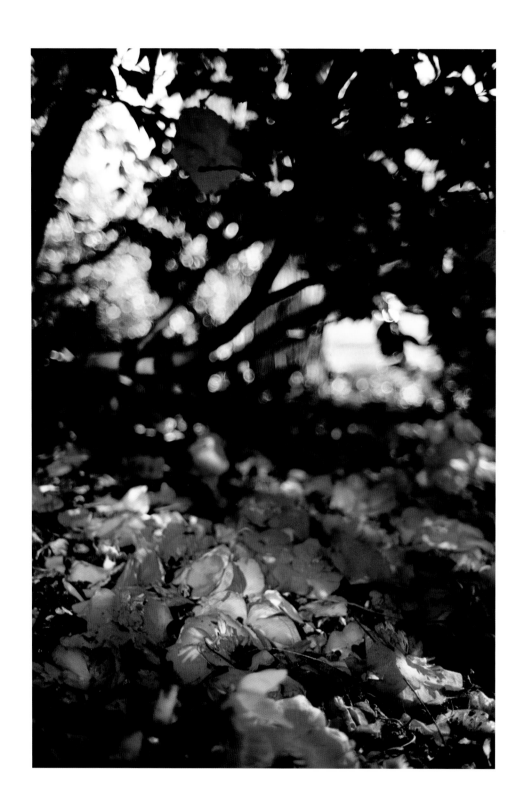

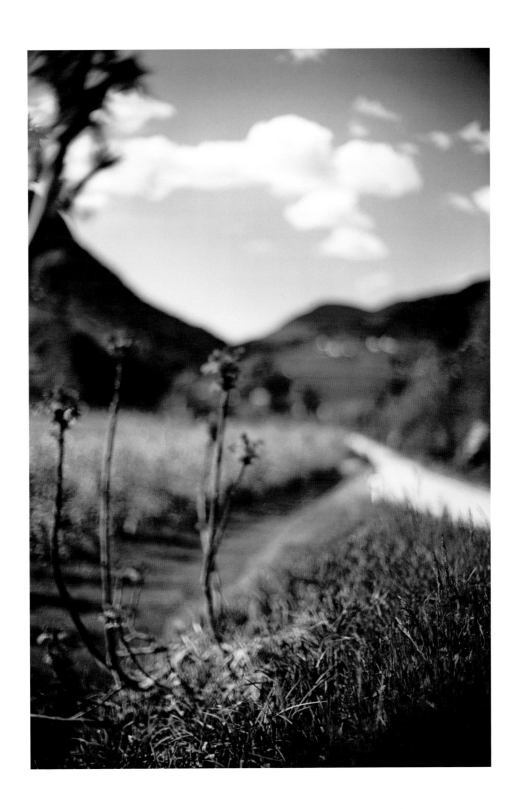

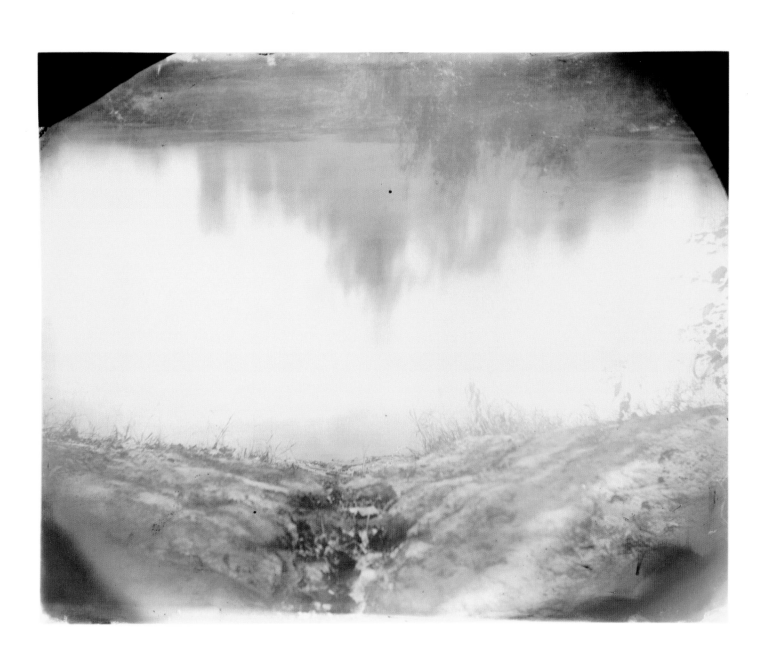

| *Untitled,* from the series *Deep South,* 1998

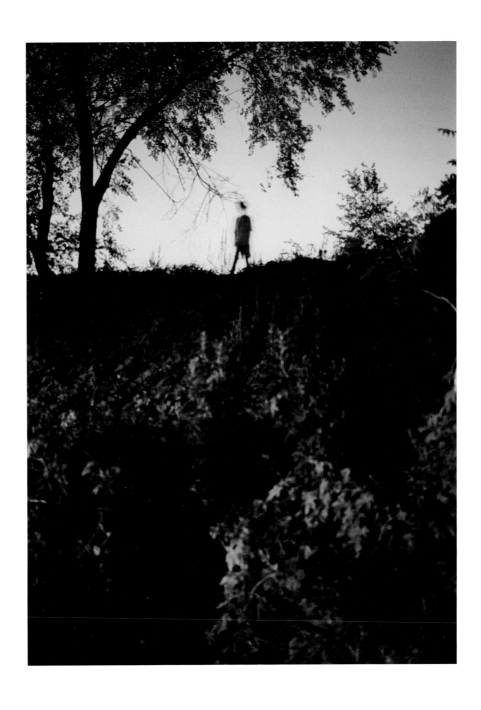

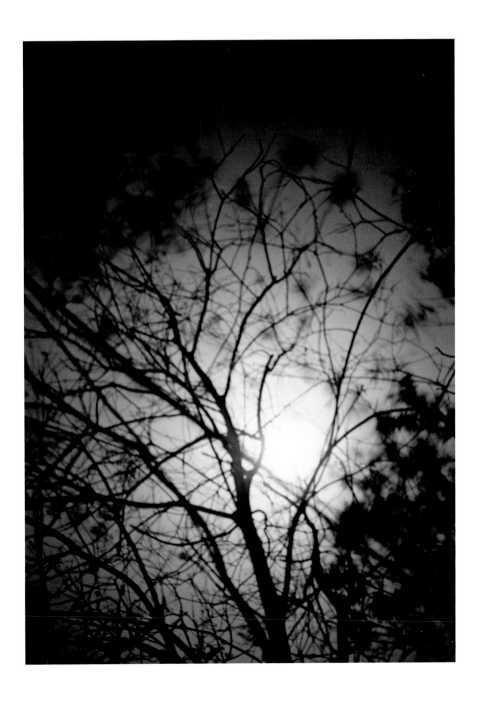

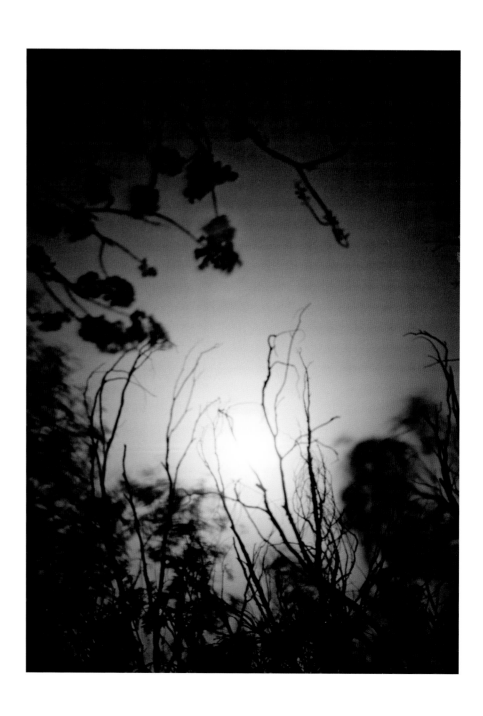

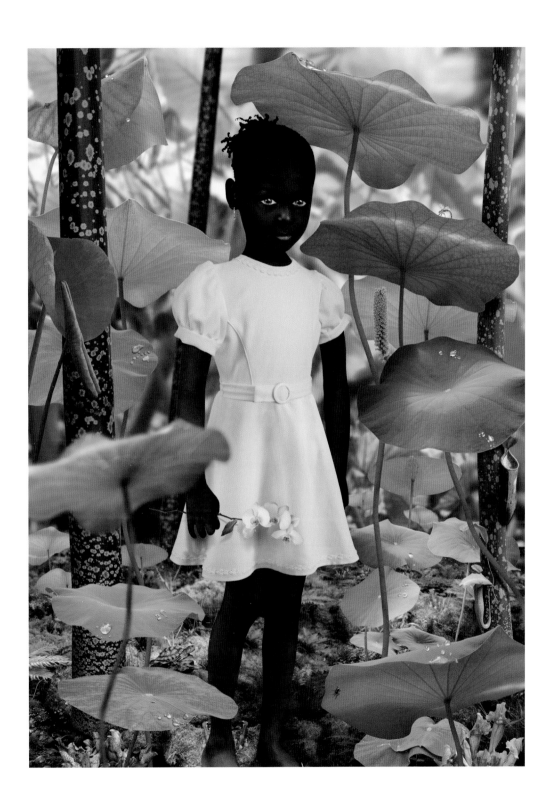

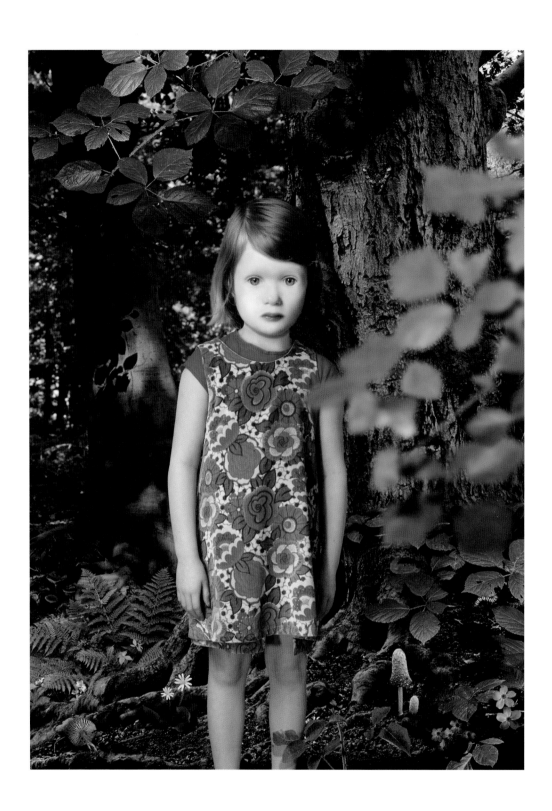

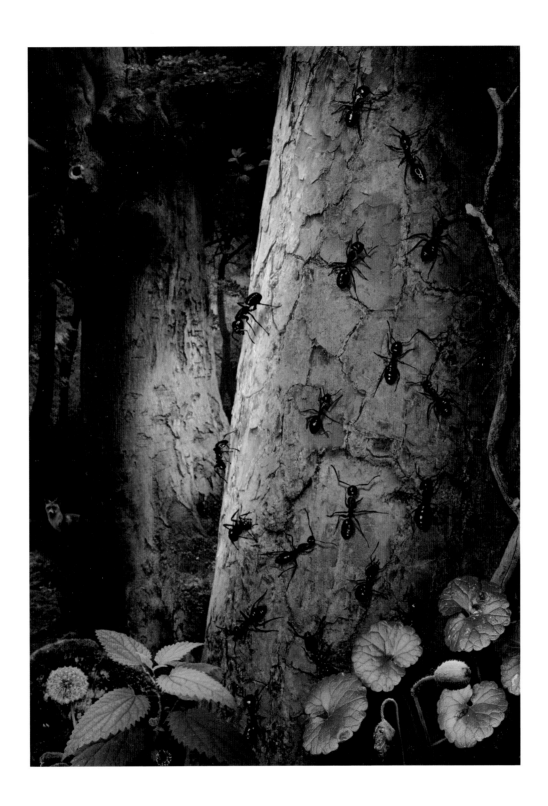

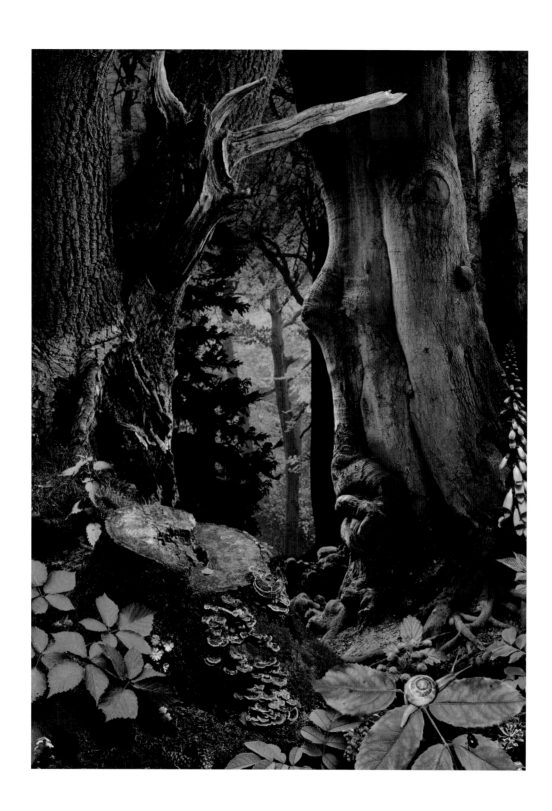

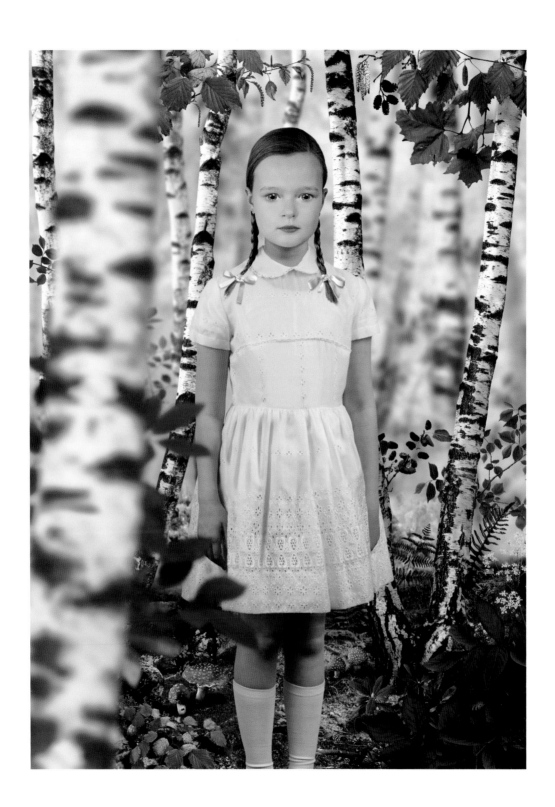

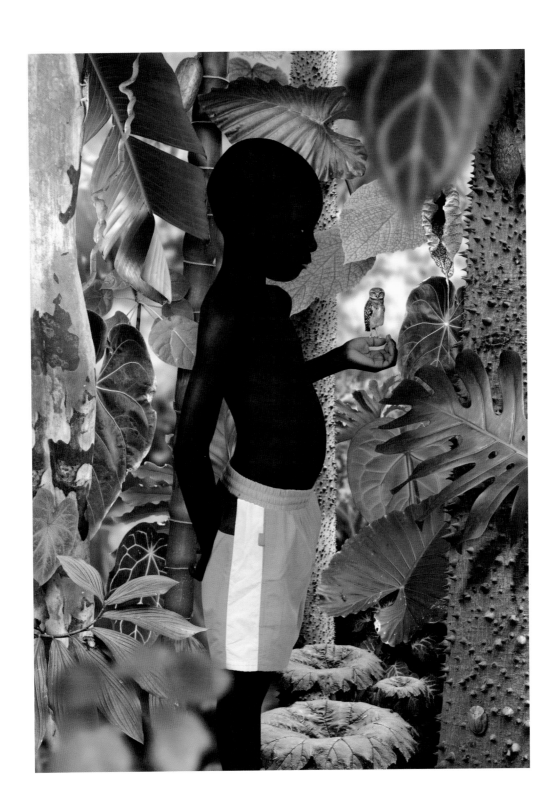

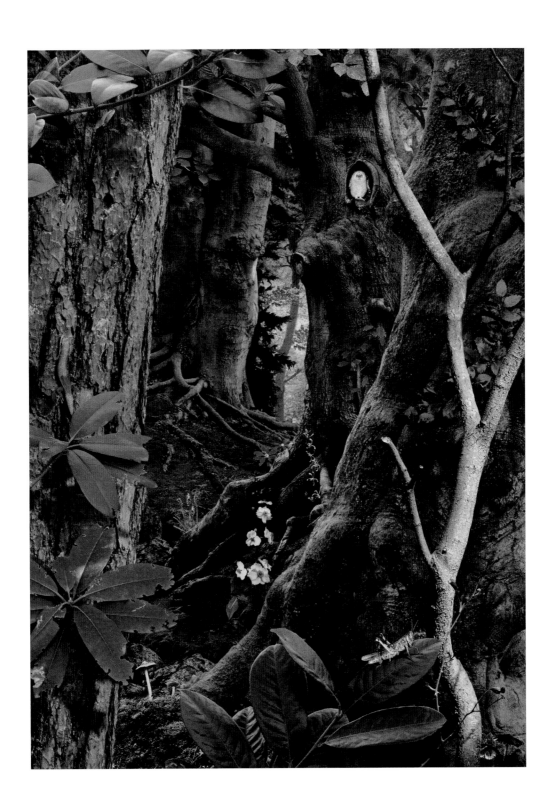

PLATES

VINCENT SERBIN
(American, born 1951)

1 | *The Power of Imagination*
1994
Gelatin silver print, toned
22 X 15½ inches
(55.9 X 39.4 cm)
Courtesy of Artist

2 | *Monumental History*
1995
Gelatin silver print, toned
21¼ X 17 inches
(54 X 43.2 cm)
Courtesy of Artist

3 | *The Omega Point Theory*
1998
Gelatin silver print, toned
16 X 22¼ inches
(40.6 X 56.5 cm)
Courtesy of Artist

4 | *Nuclear Forces*
2003
Gelatin silver print, toned
16 X 22¼ inches
(40.6 X 56.5 cm)
Courtesy of Artist

JAYNE HINDS BIDAUT
(American, born 1965)

5 | *Nature Morte*
2004
Dry plate tintypes (5)
30 X 20 inches each
(76.2 X 50.8 cm)
Courtesy of Artist and Ricco/Maresca
Gallery, New York, New York

6 | *Black Lilies*
2004
Dry plate tintype
30 X 20 inches
(76.2 X 50.8 cm)
Courtesy of Artist and Ricco/Maresca
Gallery, New York, New York

7 | *Bouquet—Spider Mum*
2004
Dry plate tintype
30 X 20 inches
(76.2 X 50.8 cm)
Courtesy of Artist and Ricco/Maresca
Gallery, New York, New York

JOSEPHINE SACABO
(American, born 1944)

8 | *Obscene Bird of Night*
2004
Gelatin silver print, solarized,
toned
12 X 10 inches
(30.5 X 25.4 cm)
Courtesy of John Stevenson Gallery,
New York, New York

9 | *The Serpent*
1990
Gelatin silver print, toned
12 X 10 inches
(30.5 X 25.4 cm)
Courtesy of John Stevenson Gallery
New York, New York

10 | *Ophelia 2*
2003
Gelatin silver print, toned
15 X 7 inches
(38.1 X 17.8 cm)
Courtesy of John Stevenson Gallery,
New York, New York

11 | *Bouquet*
2003
Gelatin silver print, toned
15 X 7 inches
(38.1 X 17.8 cm)
Courtesy of John Stevenson Gallery,
New York, New York

ADAM FUSS
(American, born 1961)

12 | *Untitled*
1998
Silver dye bleach (Cibachrome)
photogram
40 X 30 inches
(101.6 x 76.2 cm)
Courtesy of Cheim & Read,
New York, New York

13 | *Invocation*
1992
Silver dye bleach (Cibachrome)
photogram
40 X 30 inches
(101.6 x 76.2 cm)
Courtesy of Cheim & Read,
New York, New York

14 | *Love*
1993
Silver dye bleach (Cibachrome)
photogram
49 X 38¾ inches
(124.5 x 98.4 cm)
Courtesy of Cheim & Read,
New York, New York

MARK KESSELL
(Australian, born 1956)

15 | *The Residue of Vision*
2003
Pigment print on
Hanemuhle paper
50 X 40 inches
(127 X 101.6 cm)
Courtesy of Artist

16 | *A Trick of the Light*
2004
Pigment print on
Hanemuhle paper
50 X 40 inches
(127 X 101.6 cm)
Courtesy of Artist

17 | *Coelenterate*
2003
Pigment print on
Hanemuhle paper
50 X 40 inches
(127 X 101.6 cm)
Courtesy of Artist

CAMILLE SOLYAGUA
(American, born 1959)

18 | *Reptile Study #1*
1997
Gelatin silver print
8⅜ X 6⅜ inches
(21.3 X 16.2 cm)
Courtesy of Artist

19 | *Wing Study #10*
1999
Gelatin silver print
8¹¹⁄₁₆ X 6¹⁵⁄₁₆ inches
(22.1 X 17.6 cm)
Courtesy of Artist

20 | *Olivia's Nest*
1999
Gelatin silver print
8 X 7⁷⁄₁₆ inches
(20.3 X 18.9 cm)
Courtesy of Artist

21 | *Escapee*
1998
Gelatin silver print
6⅞ X 7⁷⁄₁₆ inches
(17.5 X 18.9 cm)
Courtesy of Artist

MASAO YAMAMOTO
(Japanese, born 1957)

22 | *A Box of Ku #522*
2000
Gelatin silver print
3¼ X 3 inches
(8.3 X 7.6 cm)
Courtesy of Jackson Fine Art,
Atlanta, Georgia

23 | *A Box of Ku #156*
1994
Gelatin silver print
3¾ x 3¼ inches
(9.5 x 8.3 cm)
Courtesy of Jackson Fine Art,
Atlanta, Georgia

24 | *A Box of Ku #613*
1990
Gelatin silver print
4 x 6 inches
(10.2 x 15.2 cm)
Courtesy of Jackson Fine Art,
Atlanta. Georgia

25 | *Nakazora #917*
2001
Gelatin silver print
6 x 4½ inches
(15.2 x 11.4 cm)
Courtesy of Jackson Fine Art,
Atlanta, Georgia

26 | *Nakazora #845*
1999
Gelatin silver print
4½ x 5 inches
(11.4 x 12.7 cm)
Courtesy of Jackson Fine Art,
Atlanta, Georgia

27 | *Nakazora #960*
2002
Gelatin silver print
5¼ x 3½ inches
(13.3 x 8.9 cm)
Courtesy of Jackson Fine Art,
Atlanta, Georgia

28 | *Nakazora #820*
2001
Gelatin silver print
4½ x 3 inches
(11.4 x 7.6 cm)
Courtesy of Jackson Fine Art,
Atlanta, Georgia

29 | *A Box of Ku #149*
1992
Gelatin silver print
3¼ x 1¾ inches
(8.3 x 4.4 cm)
Courtesy of Jackson Fine Art,
Atlanta, Georgia

GRETA ANDERSON
(New Zealander, born 1968)

30 | *Bat Garden, Sidney*
2002
Chromogenic development
(Lamda) print
31½ x 75⅝ inches
(80 x 192 cm)
Courtesy of Artist

31 | *Holyhocks and Balinese
Bride*
2002
Chromogenic development
(Lamda) print
31½ x 36 inches
(80 x 96 cm)
Courtesy of Artist

32 | *Purple Flowers and
Landscape*
2002
Chromogenic development
(Lamda) print
31½ x 36 inches
(80 x 96 cm)
Courtesy of Artist

JOHN PFAHL
(American, born 1939)

33 | *Bare Trees and Topiary,
Longwood Gardens, Kennett
Square, Pennsylvania*
2000
Chromogenic development
(Ektacolor) print
20 x 24 inches
(50.8 x 61 cm)
Courtesy of Janet Borden Gallery,
New York, New York

34 | *Fern Garden with Topiary,
Lotusland, Montecito, California*
2000
Chromogenic development
(Ektacolor) print
20 x 24 inches
(50.8 x 61 cm)
Courtesy of Janet Borden Gallery,
New York, New York

35 | *Highway Cactus Planting,
Tucson, Arizona*
1999
Chromogenic development
(Ektacolor) print
20 x 24 inches
(50.8 x 61 cm)
Courtesy of Janet Borden Gallery,
New York, New York

36 | *Threadleaf Japanese
Maple Tree, Hershey Gardens,
Pennsylvania*
1999
Chromogenic development
(Ektacolor) print
20 x 24 inches
(50.8 x 61 cm)
Courtesy of Janet Borden Gallery,
New York, New York

LYLE GOMES
(American, born 1954)

37 | *Bowling Green, Rousham
Park, Oxfordshire, England*
1998
Gelatin silver print
8½ x 23 inches
(21.6 x 58.4 cm)
Courtesy of Imagining Eden,
University of Virginia Press, Virginia

38 | *Hornbeam Arbour,
Ham House, England*
1998
Gelatin silver print
8½ x 23 inches
(21.6 x 58.4 cm)
Courtesy of Imagining Eden,
University of Virginia Press, Virginia

39 | *Stone Figures, Chatsworth,
England*
1998
Gelatin silver print
8½ x 23 inches
(21.6 x 58.4 cm)
Courtesy of Imagining Eden,
University of Virginia Press, Virginia

40 | *Pan, Villa Serbelloni,
Bellagio, Italy*
2002
Gelatin silver print
8½ x 23 inches
(21.6 x 58.4 cm)
Courtesy of Imagining Eden,
University of Virginia Press, Virginia

MICHAEL KENNA
(English, born 1953)

41 | *Bowood Gardens, Study 3,
Wiltshire, England*
1987
Gelatin silver print, sepia toned
8½ x 7½ inches
(21.6 x 19 cm)
Courtesy of Stephen Wirtz Gallery,
San Francisco, California

42 | *Homage to Atget, Parc de
Sceaux, Paris, France*
1988
Gelatin silver print, sepia toned
8 x 7 inches
(20.3 x 17.8 cm)
Courtesy of Stephen Wirtz Gallery,
San Francisco, California

43 | *Herm, Vaux-le-Vicompte,
France*
1996
Gelatin silver print, sepia toned
7½ x 7½ inches
(19 x 19 cm)
Courtesy of Stephen Wirtz Gallery,
San Francisco, California

44 | *Covered Urn, Versailles,
France*
1987
Gelatin silver print, sepia toned
19½ x 15½ inches
(49.5 x 39.4 cm)
Courtesy of Stephen Wirtz Gallery,
San Francisco, California

45 | *Ten and a Half Trees,
St. Petersburg, Russia*
2000
Gelatin silver print, sepia toned
7½ x 7½ inches
(19 x 19 cm)
Courtesy of Stephen Wirtz Gallery,
San Francisco, California

46 | *Perspective of Trees. Tsarskoe
Selo, Russia*
1998
Gelatin silver print, sepia toned
7 x 8½ inches
(17.8 x 21.6 cm)
Courtesy of Stephen Wirtz Gallery,
San Francisco, California

GAVIN HIPKINS
(New Zealander, born 1968)

47-58 | *The Homely*
1997-2000
Chromogenic development
prints (series of 12)
24 x 16 inches each
(60 x 40 cm)
Courtesy of Artist and Hamish McKay
Gallery, Wellington, New Zealand

47 | *The Homely: Dunedin
(Landscape)*
1999

48 | *The Homely: Auckland
(Model)*
1998

49 | *The Homely: Rotorua
(Mud)*
1999

50 | *The Homely: Rotorua
(Gateway)*
1999

51 | *The Homely: Sydney
(Flower)*
1999

52 | *The Homely: Wellington
(Museum)*
1998

53 | *The Homely: Christchurch
(Corridor)*
1998

54 | *The Homely: Christchurch
(Museum)*
1998

55 | *The Homely: Christchurch
(Icicles)*
1998

56 | *The Homely: Huka (Falls)*
1999

57 | *The Homely: Te Wairoa
(Falls)*
1999

58 | *The Homely: Wellington
(Path)*
1999

IZIMA KAORU
(Japanese, born 1954)

59 | *Ua Wears Toga #374*
2003
Chromogenic development
print
20 x 16.9 inches
(50.8 x 42.8 cm)
Courtesy of Von Lintel Gallery,
New York, New York

SIMEN JOHAN
(Norwegian, born 1973)

60 | *Untitled #86,* from
Evidence of Things Unseen
2000
Chromogenic development
print
44 x 44 inches
(111.8 x 111.8 cm)
Courtesy of Yossi Milo Gallery,
New York, New York

61 | *Untitled #70,* from *And
Nothing Was to be Trusted*
1998
Gelatin silver print, sepia toned
19 x 19 inches
(48.3 x 48.3 cm)
Courtesy of Yossi Milo Gallery,
New York, New York

62 | *Untitled #110,* from
Breeding Ground
2003
Chromogenic development
print
44 x 44 inches
(111.8 x 111.8 cm)
Courtesy of Western Project,
Los Angeles, California

LORI NIX
(American, born 1969)

63 | *Food Chain*
2002
Chromogenic development
print
20¾ x 24¾ inches
(52.7 x 62.9 cm)
Courtesy of Jenkins Johnson Gallery,
New York, New York

64 | *Salvazana*
2002
Chromogenic development
print
20¾ x 24¾ inches
(52.7 x 62.9 cm)
Courtesy of Jenkins Johnson Gallery,
New York, New York

65 | *Insect Infestation*
1998
Chromogenic development
print
20¾ x 24¾ inches
(52.7 x 62.9 cm)
Courtesy of Jenkins Johnson Gallery,
New York, New York

66 | *Wasps*
2002
Chromogenic development
print
20¾ x 24¾ inches
(52.7 x 62.9 cm)
Courtesy of Jenkins Johnson Gallery,
New York, New York

JO WHALEY
(American, born 1953)

67 | *Spheres of Influence*
1992
Chromogenic development
print
24 x 30 inches
(61 x 76.2 cm)
Courtesy of Joseph Bellows Gallery,
La Jolla, California

68 | *Meganuera*
2004
Chromogenic development
print
24 x 30 inches
(61 x 76.2 cm)
Courtesy of Robert Koch Gallery,
San Francisco, California

69 | *Harvest, the Fall*
1992
Chromogenic development
print
30 x 24 inches
(76.2 x 61 cm)
Courtesy of Robert Koch Gallery,
San Francisco, California

70 | *Cross-Pollination*
1992
Chromogenic development
print
30 x 24 inches
(76.2 x 61 cm)
Courtesy of Lisa Sette Gallery,
Scottsdale, Arizona

71 | *Othoptera: Lucifer's Apprentice*
2002
Chromogenic development print
30 x 24 inches
(76.2 x 61 cm)
Courtesy of Photo-Eye Gallery, Santa Fe, New Mexico

MAGGIE TAYLOR
(American, born 1961)

72 | *Girl With a Bee Dress*
2004
Computer generated color inkjet print
15 x 15 inches
(38.1 x 38.1 cm)
Courtesy of Artist and Laurence Miller Gallery, New York, New York

73 | *Abdullah's Prayer*
2003
Computer generated color inkjet print
15 x 15 inches
(38.1 x 38.1 cm)
Courtesy of Artist and Laurence Miller Gallery New York, New York

74 | *Southern Gothic*
2001
Computer generated color inkjet print
15 x 15 inches
(38.1 x 38.1 cm)
Courtesy of Artist and Laurence Miller Gallery New York, New York

75 | *Strange Beast*
2003
Computer generated color inkjet print
15 x 15 inches
(38.1 x 38.1 cm)
Courtesy of Artist and Laurence Miller Gallery, New York, New York

ALEC SOTH
(American, born 1969)

76 | *Green Island, Iowa*
2002
Chromogenic development print
40 x 32 inches
(101.6 x 81.3 cm)
Courtesy of Artist and Gagosian Gallery, New York, New York

77 | *Patrick, Palm Sunday, Baton Rouge, LA*
2002
Chromogenic development print
40 x 32 inches
(101.6 x 81.3 cm)
Courtesy of Artist and Gagosian Gallery, New York, New York

MATTHIAS HOCH
(German, born 1958)

78 | *Paris #31*
1999
Chromogenic development print
70¼ x 58⅛ inches
(180 x 149 cm)
Courtesy of Dogenhaus Galerie, Leipzig, Germany and Rena Bransten Gallery, San Francisco, California

79 | *Paris #28*
1999
Chromogenic development print
58½ x 72½ inches
(150 x 186 cm)
Courtesy of Dogenhaus Galerie, Leipzig, Germany and Rena Bransten Gallery, San Francisco, California

DAVID ROBINSON
(English, born 1973)

80 | *NASA Space Camp, Kita-Kyushu, Japan,* from *Wonderland*
c.1999
Chromogenic development print
9¼ x 27¼ inches
(23.5 x 69.2 cm)
Courtesy of George Eastman House, Rochester, New York

81 | *Autostadt, Wolfsburg, Germany,* from *Wonderland*
c.1999
Chromogenic development print
9³⁄₁₆ x 27⅜ inches
(23.4 x 69.5 cm)
Courtesy of George Eastman House, Rochester, New York

MICHAEL RAUNER
(American, born 1969)

82 | *Luna, Humboldt County*
2004
Computer generated color inkjet print
16 x 16 inches
(40.5 x 40.5 cm)
Courtesy of Artist

83 | *Solstice Fire Ring, Ocean Beach, San Francisco*
2004
Computer generated color inkjet print
16 x 16 inches
(40.5 x 40.5 cm)
Courtesy of Artist

84 | *Giant Rock, San Bernardino County*
2005
Computer generated color inkjet print
16 x 16 inches
(40.5 x 40.5 cm)
Courtesy of Artist

MICHAEL PAREKOWHAI
(New Zealander, born 1968)

85 | *Boulogne*
2001
Chromogenic development print
59 x 47¼ inches
(149.9 x 120 cm)
Courtesy of Michael Lett, Auckland, New Zealand

86 | *Turk Lane*
2001
Chromogenic development print
59 x 47¼ inches
(149.9 x 120 cm)
Courtesy of Michael Lett, Auckland, New Zealand

87 | *Armentières*
2001
Chromogenic development print
59 x 47¼ inches
(149.9 x 120 cm)
Courtesy of Michael Lett, Auckland, New Zealand

BINH DANH
(Vietnamese-American, born 1977)

88 | *Untitled: Soldier in Action*
2003
Chlorophyll print (leaf) and resin
7½ x 13½ inches
(19 x 34.3 cm)
Courtesy of Artist and Haines Gallery, San Francisco, California

89 | *The Conversation*
2003
Chlorophyll print (leaf) and resin
7½ x 13½ inches
(19 x 34.3 cm)
Courtesy of Artist and Haines Gallery, San Francisco, California

90 | *Battle in Folia*
2002
Chlorophyll print (leaf)
and resin
18 X 14 inches
(45.7 X 35.6 cm)
Courtesy of Artist and Haines Gallery,
San Francisco, California

91 | *Untitled #2,* from the
Lost Memories series
2004
Chlorophyll print (leaf)
and resin
14¾ X 10 X 1¼ inches
(37.5 X 25.4 X 3.2 cm)
Courtesy of Artist and Haines Gallery,
San Francisco, California

WAYNE BARRAR
(New Zealander, born 1957)

92 | *Cloned Plants (Tissue
Culture) in Medium #1, Auckland*
1996
Gelatin silver print, selenium/
gold toned
8⅞ X 5¹¹⁄₁₆ inches
(22.5 X 14.5 cm)
Courtesy of Artist

93 | *Cloned Plants (Tissue
Culture) in Medium #2, Auckland*
1996
Gelatin silver print, selenium/
gold toned
8⅞ X 5¹¹⁄₁₆ inches
(22.5 X 14.5 cm)
Courtesy of Artist

94 | *Cloned Plants (Tissue
Culture) in Medium #3, Auckland*
1996
Gelatin silver print, selenium/
gold toned
6¹¹⁄₁₆ X 8⅞ inches
(17 X 22.5 cm)
Courtesy of Artist

95 | *Cloned Plants (Tissue
Culture) in Medium #4, Auckland*
1996
Gelatin silver print, gold and
ferric toned
6¹¹⁄₁₆ X 8⅞ inches
(17 X 22.5 cm)
Courtesy of Artist

96 | *Cloned Plants (Tissue
Culture) in Medium #5, Auckland*
1996
Gelatin silver print, gold and
sulfide toned
6½ X 8¹¹⁄₁₆ inches
(16.5 X 22 cm)
Courtesy of Artist

J. JOHN PRIOLA
(American, born 1960)

97 | *Wheat Grass*
1994
Gelatin silver print
20 X 16 inches
(50.8 X 40.6 cm)
Courtesy of Artist and Gallery Paule
Anglim, San Francisco, California

98 | *15th Street, 2nd Floor*
2001
Gelatin silver print
17⅝ X 24 inches
(44.9 X 61 cm)
Courtesy of Artist and Gallery Paule
Anglim, San Francisco, California

99 | *15th Street, 3rd Floor*
2001
Gelatin silver print
17⅝ X 24 inches
(44.9 X 61 cm)
Courtesy of Artist and Gallery Paule
Anglim, San Francisco, California

100 | *Dolores Street, Ground
Floor N.*
2001
Gelatin silver print
17⅝ X 24 inches
(44.9 X 61 cm)
Courtesy of Artist and Gallery Paule
Anglim, San Francisco, California

101 | *Kearny Street*
2001
Gelatin silver print
17⅝ X 24 inches
(44.9 X 61 cm)
Courtesy of Artist and Gallery Paule
Anglim, San Francisco, California

HAN NGUYEN
(American, born 1956)

102 | *Dusk #5*
2003
Chromogenic development
(Fuji Crystal Archive Paper)
print
34¼ X 16 inches
(87 X 40.5 cm)
Courtesy of Artist, Joseph Bellows
Gallery, San Diego, California and
Stephen Cohen Gallery, Los Angeles,
California

103 | *Dusk #3*
2003
Chromogenic development
(Fuji Crystal Archive Paper)
print
30 X 24 inches
(76.2 X 61 cm)
Courtesy of Artist, Joseph Bellows
Gallery, San Diego, California and
Stephen Cohen Gallery, Los Angeles,
California

104 | *Dusk #11*
2003
Chromogenic development
(Fuji Crystal Archive Paper)
print
20½ X 20½ inches
(52 X 52 cm)
Courtesy of Artist, Joseph Bellows
Gallery, San Diego, California and
Stephen Cohen Gallery, Los Angeles,
California

105 | *Dusk #33*
2003
Chromogenic development
(Fuji Crystal Archive Paper)
print
25 X 20 inches
(63.5 X 50.8 cm)
Courtesy of Artist, Joseph Bellows
Gallery, San Diego, California and
Stephen Cohen Gallery, Los Angeles,
California

106 | *Dusk #19*
2003
Chromogenic development
(Fuji Crystal Archive Paper)
print
25 X 20 inches
(63.5 X 50.8 cm)
Courtesy of Artist, Joseph Bellows
Gallery, San Diego, California and
Stephen Cohen Gallery, Los Angeles,
California

SALLY GALL
(American, born 1956)

107 | *Oasis*
1999
Gelatin silver print
28 X 28 inches
(71.1 X 71.1 cm)
Courtesy of Julie Saul Gallery,
New York, New York

108 | *Heaven*
2001
Gelatin silver print
28 X 36 inches
(71.1 X 91.4 cm)
Courtesy of Julie Saul Gallery,
New York, New York

109 | *Messenger*
2001
Gelatin silver print
36 X 28 inches
(91.4 X 71.1 cm)
Courtesy of Julie Saul Gallery,
New York, New York

LIZ RIDEAL
(English, born 1954)

110 | *Jamming*
2002
Chromogenic development print
16 x 16 inches
(40.5 x 40.5 cm)
Courtesy of HackelBury Fine Art, London, England and Lucas Schoormans Gallery, New York, New York

111 | *Pirouette*
2002
Chromogenic development print
16 x 16 inches
(40.5 x 40.5 cm)
Courtesy of HackelBury Fine Art, London, England and Lucas Schoormans Gallery, New York, New York

112 | *Fred & Ginger*
2002
Chromogenic development print
16 x 16 inches
(40.5 x 40.5 cm)
Courtesy of HackelBury Fine Art, London, England and Lucas Schoormans Gallery, New York, New York

MIKE AND DOUG STARN
(American, born 1961)

113 | *Black Pulse #17 (Lambda)*
2000-05
Chromogenic development (Lambda) print
34 x 70 inches
(86.4 x 177.8 cm)
Courtesy of Doug and Mike Starn, Artist's Rights Society, New York, New Yorky

114 | *Structure of Thought #2*
2001-05
Computer generated color inkjet (MIS and Lysonic) prints on Thai mulberry, Gampi, and tissue papers, wax, encaustic, varnish
72 x 60 inches
(182.9 x 152.4 cm)
Courtesy of Doug and Mike Starn, Artist's Rights Society, New York, New York

115 | *Structure of Thought #15*
2001-05
Computer generated color inkjet (MIS and Lysonic) prints on Thai mulberry, Gampi, and tissue papers, wax, encaustic, varnish
60 x 72 inches
(152.4 x 182.9 cm)
Courtesy of Doug and Mike Starn, Artist's Rights Society, New York, New York

JOANN VERBURG
(American, born 1950)

116 | *Tango / Tangle*
1999
Chromogenic development (Fuji Crystal Archive Paper) prints (2)
40 x 28¼ inches each
(101.6 x 71.8 cm)
Courtesy of G. Gibson Gallery, Seattle, Washington

117 | *Olive Trees After the Heat*
1998
Chromogenic development (Fuji Crystal Archive Paper) prints (4)
40 x 28¼ inches each
(101.6 x 71.8 cm)
Courtesy of G. Gibson Gallery, Seattle, Washington

JIŘI ŠIGUT
(Czech, born 1960)

118 | *Coast—Ice*
15.-30.12.2002
Photogram, toned
29¾ x 38⁷/₁₆ inches
(75.5 x 97.5 cm)
Courtesy of Artist

119 | *Grass*
23.-30.1.2001
Photogram, toned
38⅝ x 38⅝ inches
(98 x 98 cm)
Private collection of Mr. Lekeš

120 | *Broken Stalks—Snow*
8.-16.2. 2004
Photogram, toned
39 x 27½ inches
(99 x 70 cm)
Courtesy of Artist

121 | *Lagoon—Water Level*
22.10.-5.11.2000
Photogram, toned
17⅜ x 21⅜ inches
(44 x 54 cm)
Courtesy of Artist

122 | *Lagoon—Water Level*
12.-22.11.2000
Photogram, toned
21⅜ x 17⅜ inches
(54 x 44 cm)
Courtesy of Artist

SUSAN DERGES
(English, born 1955)

123 | *The Streens—Spawn*
2002
Chromogenic development (Ilfachrome) photogram
66⅛ x 23½ inches
(168 x 59.7 cm)
Courtesy of Paul Kasmin Gallery, New York, New York

124 | *The Streens—Larch*
2002
Chromogenic development (Ilfachrome) photogram
66⅛ x 23½ inches
(168 x 59.7 cm)
Courtesy of Paul Kasmin Gallery, New York New York

EDWARD DIMSDALE
(English, born 1965)

125 | *Temple Pond, Kyoto*
2003
Gelatin silver prints from paper negative (5)
51¼ x 19¾ inches
(130 x 50 cm)
Courtesy of Hackelbury Fine Art, London, England

TERRI WEIFENBACH
(American, born 1957)

126 | *Lana Series #4*
1998-2001
Chromogenic development (RA-4) print
24 x 20 inches
(61 x 50.8 cm)
Courtesy of Artist

127 | *Lana Series #8*
1998-2001
Chromogenic development (RA-4) print
24 x 20 inches
(61 x 50.8 cm)
Courtesy of Artist

128 | *Lana Series #60*
1998-2001
Chromogenic development (RA-4) print
24 x 20 inches
(61 x 50.8 cm)
Courtesy of Artist

129 | *Lana Series #66*
1998–2001
Chromogenic development
(RA-4) print
24 x 20 inches
(61 x 50.8 cm)
Courtesy of Artist

130 | *Lana Series #68*
1998–2001
Chromogenic development
(RA-4) print
24 x 20 inches
(61 x 50.8 cm)
Courtesy of Artist

131 | *Lana Series #48*
1998–2001
Chromogenic development
(RA-4) print
24 x 20 inches
(61 x 50.8 cm)
Courtesy of Artist

SALLY MANN
(American, born 1951)

132 | *Untitled,* from the series
Deep South
1998
Gelatin silver print from wet
collodion negative
40 x 50 inches
(101.6 x 127 cm)
Courtesy of George Eastman House,
Rochester, New York

HONGBIN SUN
(Chinese, born 1970)

133 | *Darkness 10*
2003
Chromogenic development
print (120 Fuji Negative on
Kodak Paper)
31½ x 22⅝ inches
(80 x 57.4 cm)
Courtesy of Chinese Artist Network
(CAN), Fremont, California

134 | *Darkness 2*
2002
Chromogenic development
print (120 Fuji Negative on
Kodak Paper)
31½ x 22⅝ inches
(80 x 57.4 cm)
Courtesy of Chinese Artist Network
(CAN), Fremont, California

135 | *Darkness 3*
2002
Chromogenic development
print (120 Fuji Negative on
Kodak Paper)
31½ x 22⅝ inches
(80 x 57.4 cm)
Courtesy of Chinese Artist Network
(CAN), Fremont, California

136 | *Darkness 4*
2002
Chromogenic development
print (120 Fuji Negative on
Kodak Paper)
31½ x 22⅝ inches
(80 x 57.4 cm)
Courtesy of Chinese Artist Network
(CAN), Fremont, California

137 | *Darkness 5*
2002
Chromogenic development
print (120 Fuji Negative on
Kodak Paper)
31½ x 22⅝ inches
(80 x 57.4 cm)
Courtesy of Chinese Artist Network
(CAN), Fremont, California

RUUD VAN EMPEL
(Dutch, born 1958)

138 | *World #1*
2005
Silver dye bleach (Cibachrome)
print, Dibond, plexiglass
46¹³⁄₁₆ x 33⅛ inches
(118.9 x 84.1 cm)
Courtesy of TZR Galerie,
Bochum, Germany

139 | *Study in Green #17*
2004
Silver dye bleach (Cibachrome)
print, Dibond, plexiglass
23⅝ x 16¹⁵⁄₁₆ inches
(60 x 43 cm)
Courtesy of TZR Galerie,
Bochum, Germany

140 | *Study in Green #18*
2004
Silver dye bleach (Cibachrome)
print, Dibond, plexiglass
46¹³⁄₁₆ x 33⅛ inches
(118.9 x 84.1 cm)
Courtesy of TZR Galerie,
Bochum, Germany

141 | *Study in Green #2*
2003
Silver dye bleach (Cibachrome)
print, Dibond, plexiglass
46¹³⁄₁₆ x 33⅛ inches
(118.9 x 84.1 cm)
Courtesy of TZR Galerie,
Bochum, Germany

142 | *Untitled #1*
2004
Silver dye bleach (Cibachrome)
print, Dibond, plexiglass
46¹³⁄₁₆ x 33⅛ inches
(118.9 x 84.1 cm)
Courtesy of TZR Galerie,
Bochum, Germany

143 | *World #3*
2005
Silver dye bleach (Cibachrome)
print, Dibond, plexiglass
46¹³⁄₁₆ x 33⅛ inches
(118.9 x 84.1 cm)
Courtesy of TZR Galerie,
Bochum, Germany

144 | *Study in Green #10*
2003
Silver dye bleach (Cibachrome)
print, Dibond, plexiglass
46¹³⁄₁₆ x 33⅛ inches
(118.9 x 84.1 cm)
Courtesy of TZR Galerie,
Bochum, Germany

BIOGRAPHIES

DEBORAH KLOCHKO is an author and curator with twenty year's experience in photography museums as an educator, director, and curator. Formerly the Director of The Friends of Photography located at the Ansel Adams Center, Ms. Klochko curated seventeen exhibitions, and was executive editor of *see*, an award-winning journal of visual culture.

Currently, she is co-curator of the exhibition and book *Create and Be Recognized: Photography on the Edge* and co-author of *The Moment of Seeing: Minor White at the California School of Fine Arts*. In addition, she is the founder of *Speaking of Light: Oral Histories of American Photographers*.

ANTHONY BANNON is the seventh director of the George Eastman House.

MERRY FORESTA is director of the Smithsonian Photography Initiative. SPI explores the mulit-faceted role of photography as viewed through the Institution's collection of over 13 million photographs. Her previous books include *Perpetual Motif: The Photography of Man Ray; Between Home and Heaven: Contemporary Landscape Photograph; Secrets of the Dark Chamber: The Art of the American Daguerreotype*; and *At First Sight: Photography and the Smithsonian*.

LOUISE MOZINGO joined the Department of Landscape Architecture and Environmental Planning at the University of California, Berkeley, after Bay Area practice as a landscape architect. She is the recipient of Harvard University's Dumabarton Oaks Fellowship for Studies in Landscape Architecture. Her articles have appeared in *Places, Landscape Journal, Journal of the History of Gardens and Designed Landscapes, Landscape Architecture*, and the *Journal of the Society of Architectural Historians*.

REBECCA SOLNIT is an award winning writer, historian and activist. Her books include *A Book of Migrations: Some Passages in Ireland* (1997), *Hollow City: The Siege of San Francisco and The Crisis of American Urbanism* (2000), *As Eve Said to the Serpent: On Landscape, Gender, and Art and Wanderlust* (2001), *River of Shadows: Eadweard Muybridge and the Technological Wild West* (2003), and *A Field Guide to Getting Lost* (2005).

PICTURING EDEN WAS MADE POSSIBLE through the support and hard work of many people. First among these has been the staff of the George Eastman House International Museum of Photography and Film, whose dedication to both the history of photography and to the exploration of contemporary issues in the field has been essential to the success of this project. George Eastman House is supported by public funds from the New York State Council on the Arts, the Institute of Museum and Library Services, the National Endowment for the Arts, the County of Monroe, and by private contributions from individuals, corporations, and foundations.

I would like to express my appreciation to the George Eastman House staff for their dedication to the project, particularly to museum director Anthony Bannon, Mark Beeman, Jennifer Curtis, Barbara Galasso, Rick McKee Hock, Joan Krauszer, Wataru Okada, Kurtis Unruh-Kracke and Jeanne Velhurst.

I would also like to thank Stephanie Comer, Merry Foresta, Nora Kabat, Katka Kastnerova, Dan Meinwald, Louise Mozingo, Irene Rietschel, Rebecca Solnit, Jo Tartt, Jr., Lori Theriault, Michi Toki, and John B. Turner for their invaluable contributions.

Special thanks are due to the Comer Foundation, Creative New Zealand, and the Mondriaan Foundation.

Finally, my deepest gratitude to my parents, Laura and George Klochko, my sister Janet Klochko, and my husband Gary Singer for their understanding and unwavering faith in me.

Deborah Klochko